GLOSSOPDALE

THROUGH TIME

Mike Brown
& Sue Hickinson

Mike Brown Sue Hickinson

AMBERLEY PUBLISHING

Acknowledgements

The authors would like to thank the many people who have helped by giving or loaning us postcards and other images over the years. Amongst these we should mention Glossop Heritage Trust, Stan Parker, Jean Hollins, Keith Holford, Graham Hadfield, Philip Battey, Barry Marsden, Carol Hughes, the families of Jack Holden, Roy Raddon, Frank Dearnley and Jim Chatterton. Not forgetting our spouses, Mari Brown and John Hickinson for not complaining too much whilst this volume was compiled between two homes.

First published 2012

Amberley Publishing
The Hill, Stroud
Gloucestershire, GL5 4EP

www.amberley-books.com

Copyright © Mike Brown & Sue Hickinson, 2012

The right of Mike Brown & Sue Hickinson to be identified as the Authors of this work has been asserted in accordance with the Copyrights, Designs and Patents Act 1988.

ISBN 978 1 4456 0771 9

British Library Cataloguing in Publication Data. A catalogue record for this book is available from the British Library.

Typeset in 9.5pt on 12pt Celeste.
Typesetting by Amberley Publishing.
Printed in the UK.

Introduction

Perhaps a more accurate title for this volume should be *Glossopdale Through Photographically Recorded Time*, which in our case is from the late 1880s. We would like to be able to show the Glossopdale Manor, Parish or Borough through time, even just recorded time, so the viewer could see the valley from the distant past, from Roman times and to the scene before the late eighteenth century when the industrial revolution and the cotton industry changed it forever.

There certainly must have been even more water in the valley bottom, with lakes and pools fed by Glossop Brook and its various tributary streams – Shelf Brook, Blackshaw, Hurst and Bray Cloughs. Smaller streams that came down the valley sides from the Nab and Mouselow have vanished under houses and the mills to which they were so important for power and manufacturing processes. Natural floodplain lakes were replaced by many interlinked mill ponds, holding sufficient water for the mills, and these were a feature of the valley, as were the deepened and straightened sections of Glossop Brook, made to run the frequent flash floods away from the mills and workers' houses. The many photographs of Dinting Vale show how what was once a large lake was utilised by Potter's Dinting Printworks and turned into a catchment lake and a series of ponds.

The earliest views we have are of Dinting. There are engravings and watercolours of the original Dinting Arches, and there is an earlier painting entitled 'Dinting Mill' by Thomas Christopher Hofland which, with a little artistic licence, shows Lyne's Boggart Mill before Edmund Potter's Printworks transformed the valley. Probably the earliest image of the more easterly area, the Howardtown of the early nineteenth century, which from the 1840s became the 'New Town' of Glossop, built round its new Town Hall and railway station, is a view across to the east, from the top of what is now Philip Howard Road, toward the Town Hall and John Wood's Howardtown Mills. As this photograph shows the Glossop Brook still flowing in the open across the market ground site behind the extended indoor market and open fish market, it must be from before 1887, as Lord Howard had the water course covered and the market ground extended by then.

Usually somewhere in the region of fifty old photographs of Glossop can be found for sale on internet auctions and there are many avid collectors of old postcards. Many postcards are commercial products and there were many local photography studios in existence for a while, although some, like the well-known Battey firm, lasted far longer than others.

Photographs of many family groups, as well as scenes, were taken, developed and printed by local amateurs. These often have the usual 'postcard' printing on the back as this was how the printing paper was bought, so that copies, with the addition of a message and a half penny stamp, could be sent to relatives and friends.

Our first thought on deciding to produce this volume was not just which of the hundreds of available images we should use, but how could we replicate them without having to stand in the middle of busy roads. Therefore, some modern photographs have had to be taken from the roadside for safety reasons.

Another problem was that we realised for every scene where the buildings had been changed, or fields built over, there were places where we couldn't see the view for trees, such has been the growth of mature woodland, even in the very centre of the town.

The local scene changes weekly, if not daily, and even over the period of the production of this volume some things, particularly shops, have changed. In a series of old pictures it is obvious that, backed up by the evidence of censuses and trade directories, shops changed hands and type of business just as often then.

The local authority often tries to ensure that when premises are being changed in the town centre, old photographs are consulted if possible, to try to keep a sense of Glossop's past in the design of the shop, and unsuitable fittings are replaced with period style frontages.

In many old photographs, usually taken on Sundays, of church or chapel processions, the main street looks bleak as shops had shutters up, many of which seem to be covered with fly posters and the buildings are soot-blackened from the many domestic and industrial chimneys in the valley.

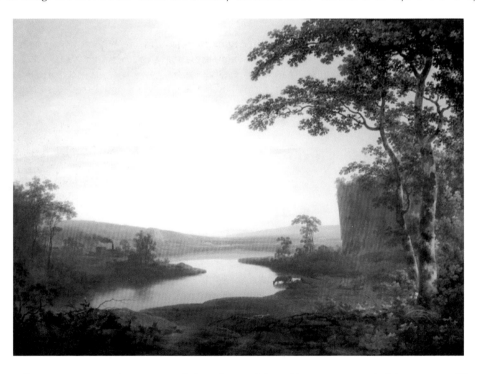

The earliest painting we have seen of the Glossopdale valley is one entitled 'Dinting Mill', and believed to be by Thomas Christopher Hofland painted *c.* 1827 and in all probability commissioned by Edmund Potter, as it shows an artist's stylised and composite view of the area soon to be filled with his Dinting Printworks factories. The view today is impossible to reproduce. (Painting by kind permission of Christopher Foley, Lane Fine Art, London.)

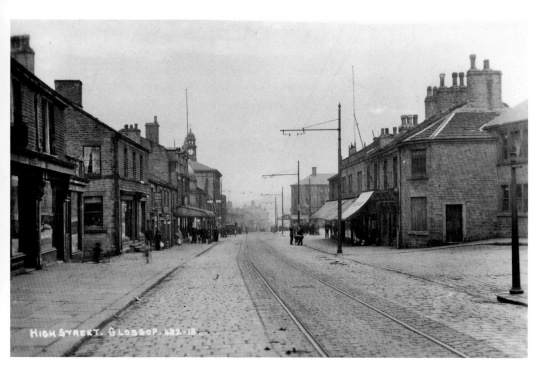

HIGH STREET. GLOSSOP. 1422-15

High Street East looking West

The recent photograph, taken on a quiet Sunday morning, shows only detailed differences as the individual shop names are not in evidence. There are a few extra windows and modern street lights and the tram tracks and poles have gone, along with the glass and iron arcades round the Co-op and Brownson's Corner. The Barclay's Bank building on the right does stand out, being higher than the earlier Hepworth shop.

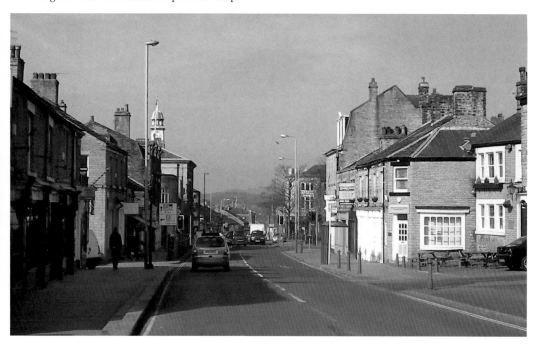

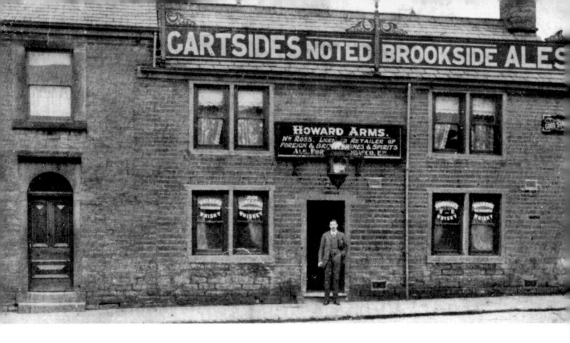

The Howard Arms

Once an alehouse on the edge of the Chapel-en-le-Frith to Enterclough Bridge Turnpike, the Howard, built *c.* 1800, is one of the oldest buildings in the town. It was here when 'Glossop' was a village over half a mile away and the area was yet to even become 'Howardtown', a cotton mill site. The cobbled forecourt is no longer a parking spot but used for the clientele of the pub to sit outside and drink.

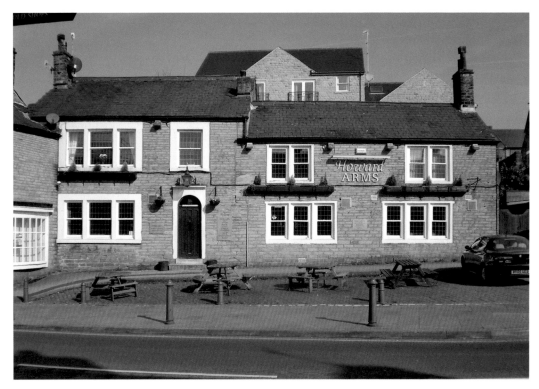

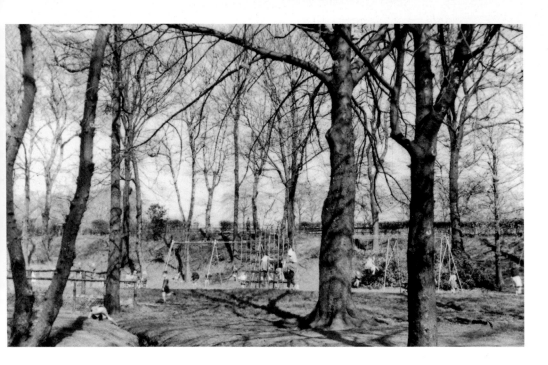

'The Swings'

The children's playground in Manor Park is always popular and those of us over fifty will recognise the old swings, roundabouts, monkey bars and paddling pool. The new version seems very tame by comparison, with child-safe soft ground surfaces, although one of the authors still has a scar on the back of the head, after fifty-seven years, from falling off a swing he shouldn't have been on, or, in fact, even been in the playground on his own.

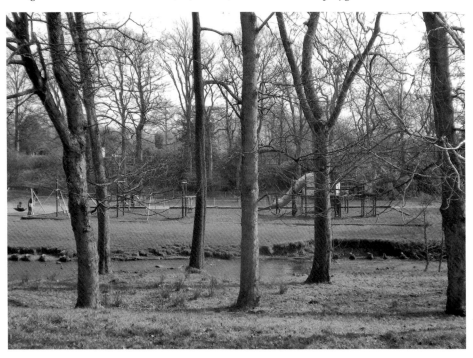

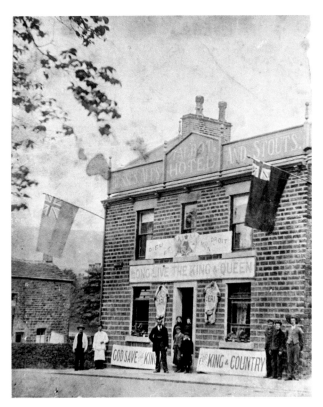

Talbot Hotel
The signs by the door tell us the landlady, Emma Handford, and her staff are celebrating the coronation of Edward VII. Now, appearing to be smaller without the roof signs, plus a larger shop window, the building has gone from being Bridge House in 1841 to Bridge Inn, Talbot Arms, Talbot Hotel, and then a post office, a bed & breakfast and finally a private house.

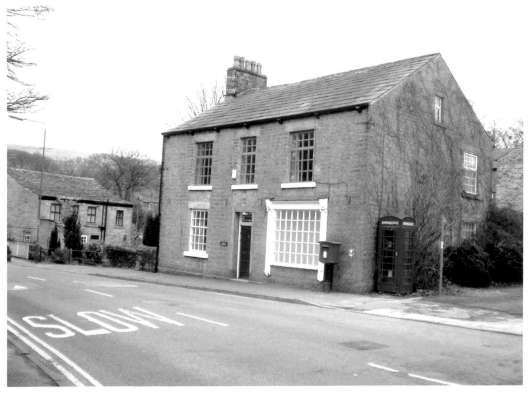

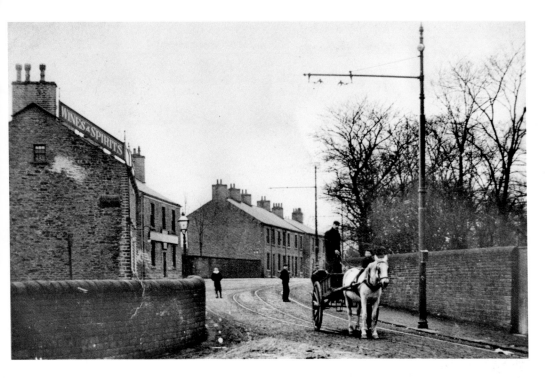

From The Queen's to The Commercial, Hall Street
Now Manor Park Road has the park on one side for almost its full length. This old view, taken from The Queen's, looks south towards two other former pubs, the Talbot across the bridge and the Hare and Hounds beyond it. The gap in the buildings beyond, now filled by red brick terraced houses, was used for the 'Wild Weekend', a local carnival of legendary proportions celebrated locally for many years.

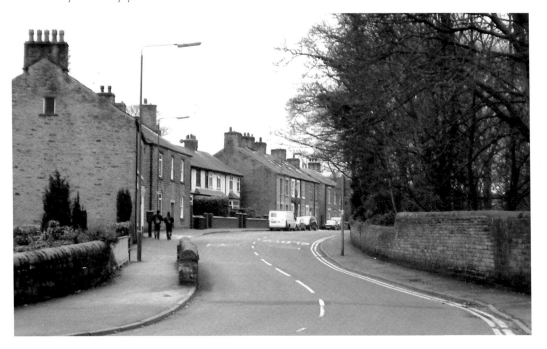

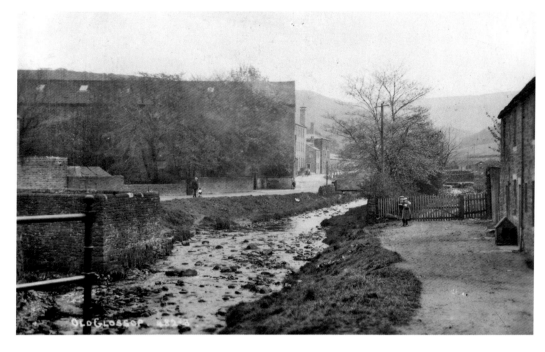

Wharf Brook from Manor Park Road Bridge

Shelf Brook, sometimes known as Wharf Brook, is joined near the Manor Park Road bridge by the Blackshaw Brook flowing alongside Wesley Street. The square enclosure at the junction is the old pinfold where stray cattle would be impounded until claimed by their owners. Here the dark bulk of Shepley's Mill stands next to the road alongside the mill owner's house. The houses on the right were semi-derelict for many years before being renovated and restored as attractive stream-side homes.

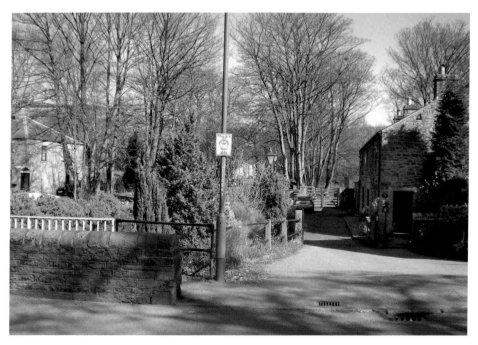

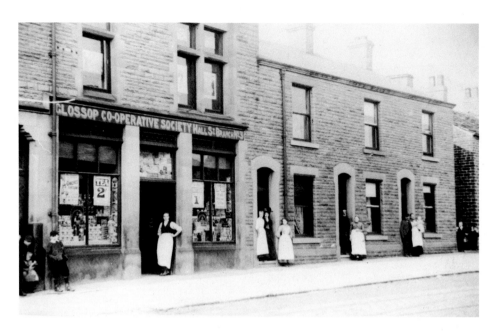

Glossop, Co-operative Society, Hall Street Branch

One of the Glossop Co-operative Society's branches was to be found at the south end of Hall Lane, later Hall Street, now Manor Park Road, but usually known to the locals as 'turn'o'th lane'. The premises are now Martin's Manor Stores and the Old Glossop post office.

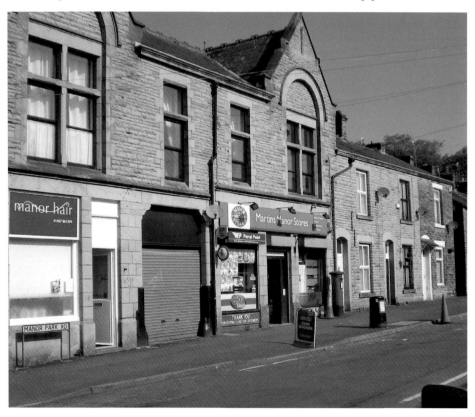

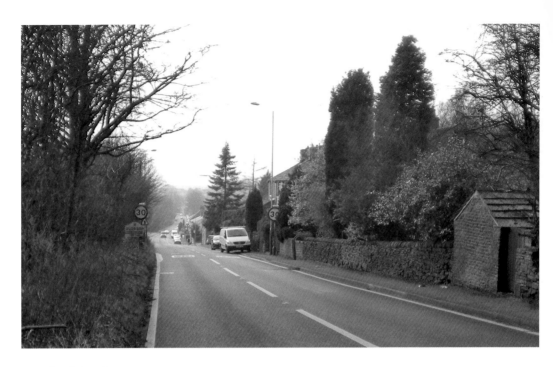

Woodcock Road

These cottages on Woodcock Road below the old Snake Turnpike Toll bar could be said to be the first houses of Glossop. Although there is now a better footpath on the opposite side of the road, there seems to be little difference, until further down beyond the Pyegrove path and Queen's Drive. The modern view shows the red-brick houses on the right but the ones between Hurst Road and Shirebrook are hidden by the hedge on the left.

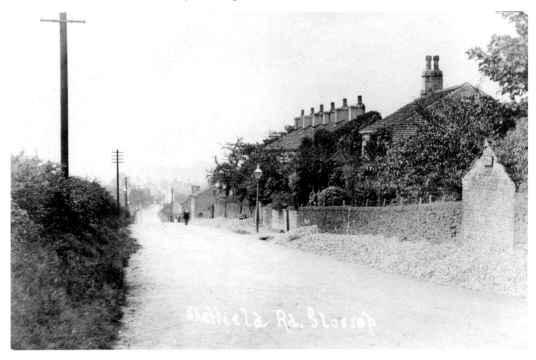

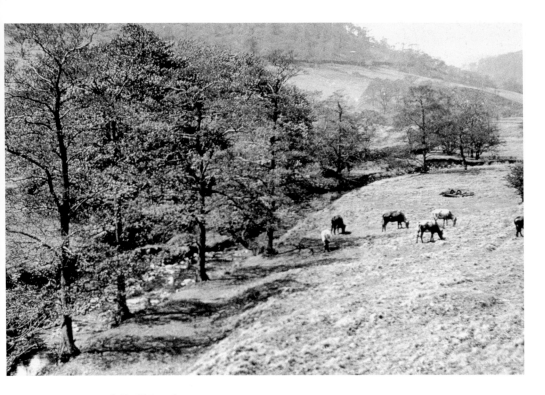

Mossy Lea and Shelf Brook

In comparison, not much seems to have changed since the 1930s in the fields next to the path above Mossy Lea Farm, apart from a slight change in the course of the brook and a small tree in the hole which is all that remains of a small water-powered bone mill.

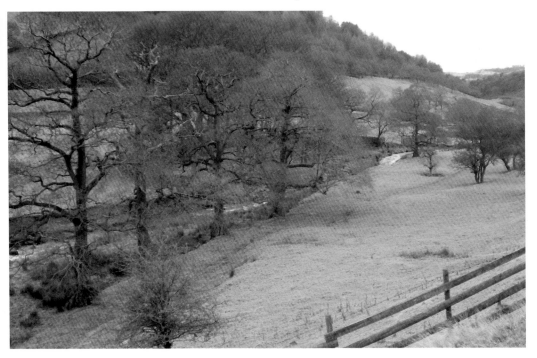

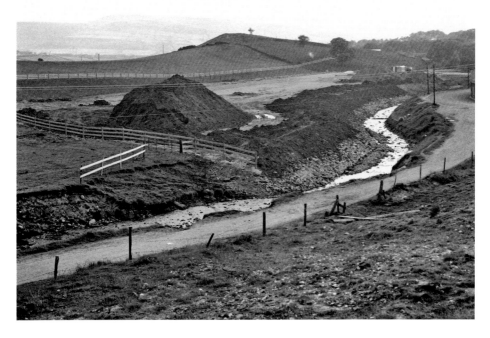

Shelf Brook and Ryecroft Hill
The view southwards of the fields across Shelf Brook towards Ryecroft Hill from the site of the old Thread Mill was taken in the 1960s and the site clearance has begun for the building of the Firth Rixson factory.

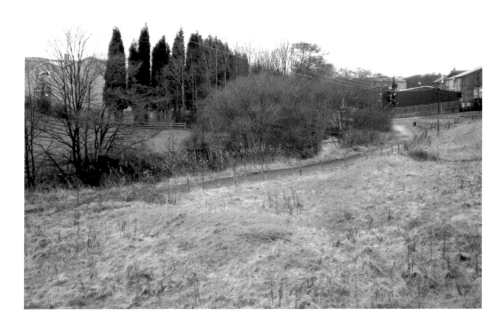

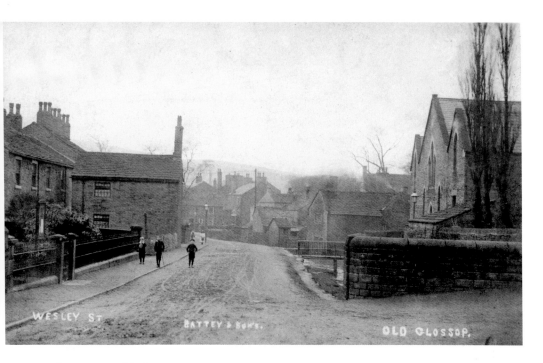

Wesley Street, Old Glossop

Wesley Street was formerly Brookside and the modern view shows a wall along the edge of Blackshaw Clough from Salford Bridge at the bottom of Wellgate, probably to contain the frequent floods that came down from the hills. The railings of the 1813 Wesleyan Chapel, which later became a factory and is now a house, have been replaced by a stone wall at some time. The first cottages beyond the chapel were originally Rolfe's Mill and warehouse.

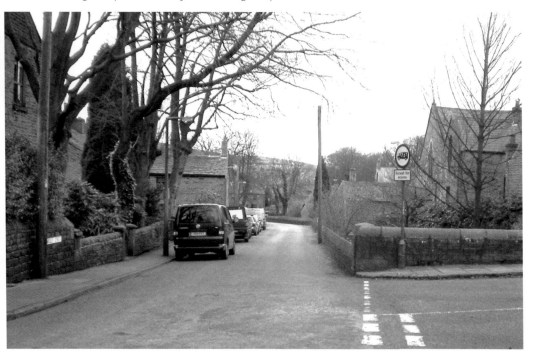

15

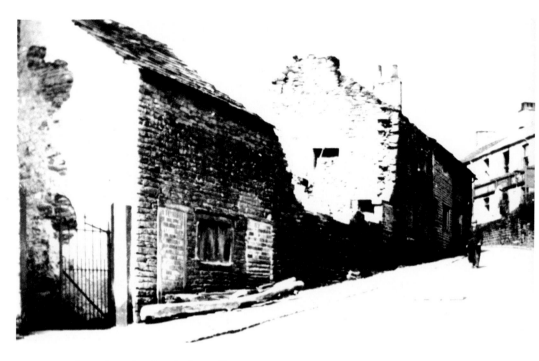

Wellgate, The Wheatsheaf and The Bull

Many of the old properties on Wellgate were demolished by the late 1960s. The entrance to the new one-way road system came out opposite these cottages, believed to have once been a coffin makers.

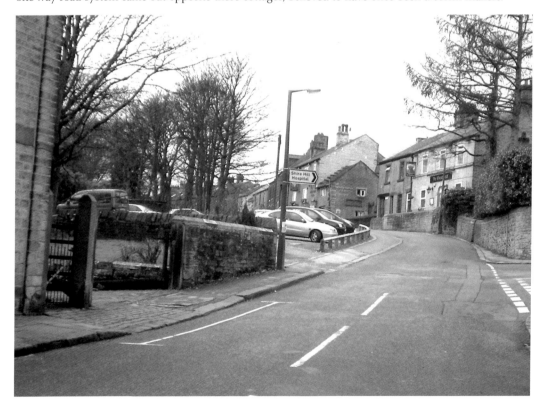

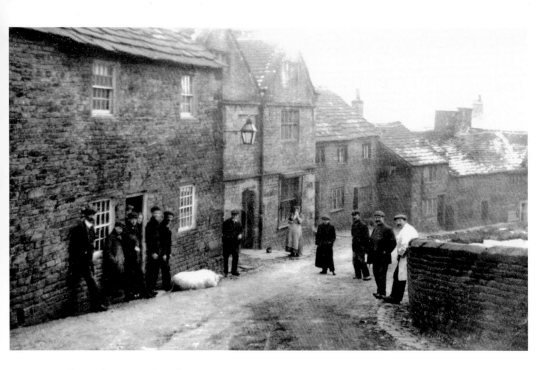

Woodhouse's Brow, Church Street, Old Glossop

The part of Church Street behind the church was formerly just 'The Street', but known to most locals as Woodhouse's Brow as the lower part of the double-fronted house at the top was Woodhouse's Butcher shop. The shuttered shop window inserted in the old house was removed and the original style of window was replaced in the 1960s. Here, on a misty snowy day, it appears that the week's ham and bacon is about to be prepared by the shop slaughterman.

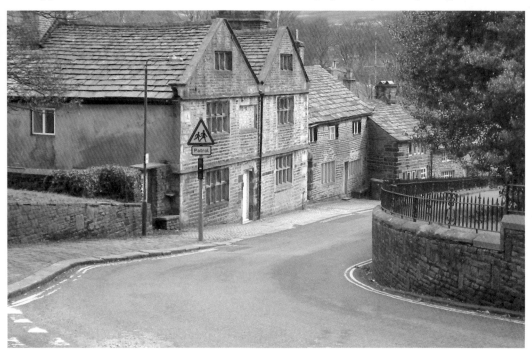

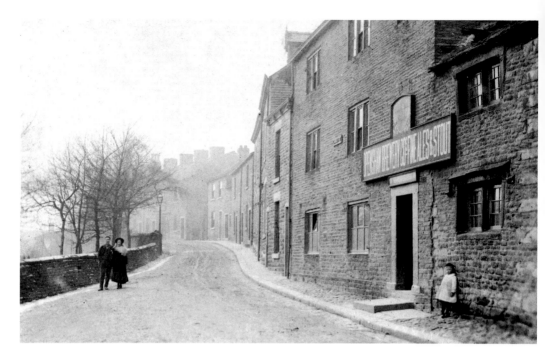

The Bull's Head, Church Street, Old Glossop

The Bull's Head has some interesting architecture at the east end, showing the original style of the building, supposedly erected in 1607. It has been an alehouse and inn since 1753 and the famous Glossop Handbell ringers used the Bull as their headquarters. There is reputedly a 'tie-ring' under the road to tether a bull for baiting with dogs, hence the name of the building. Today, with seating outside, it serves renowned curries. The background seems almost unchanged.

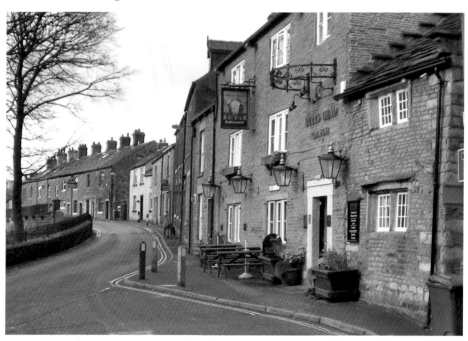

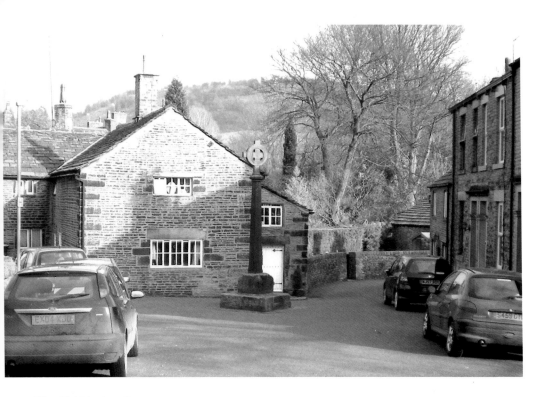

The Old Market Cross

The old photograph must be dated between 1907 and 1912, as the Old Market Cross is in the centre of the road but without the Celtic Cross placed on top in 1912. The houses on the right have been demolished and the new ones are yet to be built. The modern view shows that the road surface has been raised around the cross so the bottom stones are now level with the tarmac.

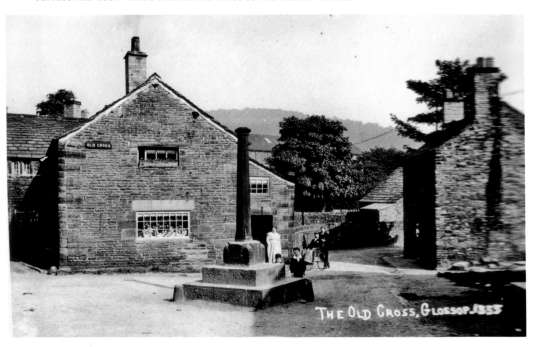

THE OLD CROSS, GLOSSOP J355

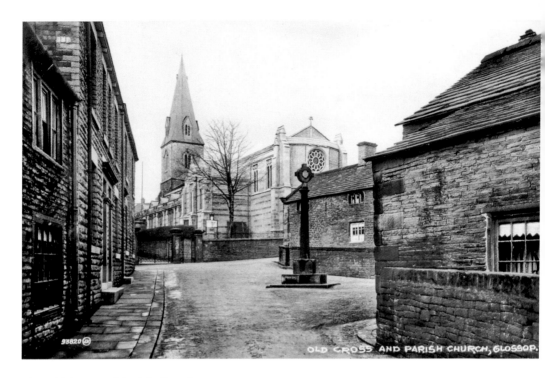

The Old Cross and Parish Church

This familiar view of the Old Cross area shows that there have been few changes to the area since the parish church was rebuilt in 1914 and 1924. Raising the tarmac to the level of the bottom plinth of the cross has widened the road, but the removal of the stone bumpers, originally placed there to protect the cross from cart wheels, has meant that in April 2012 a vehicle was able to damage the cross base.

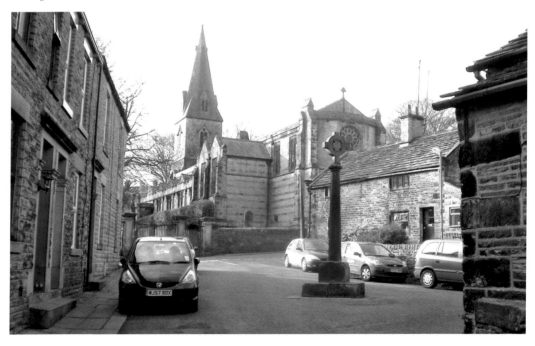

Glossop Parish Church

The parish churchyard was once an open area, having a road entering from the south across the Royle, other paths up to Castle Hill, and a route westwards to Hadfield. At some time, probably in the 1850s when the school was built and the vicarage and the church were rebuilt, railings divided up the graveyard and vicarage. The trees blocking the view of the church itself in this *c.* 1900 view are now gone along with most of the railings.

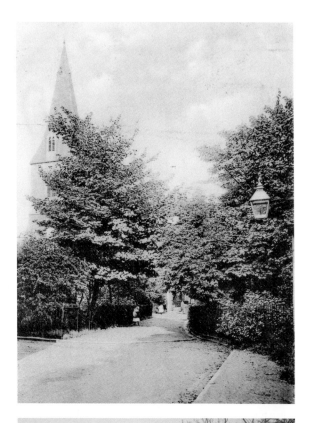

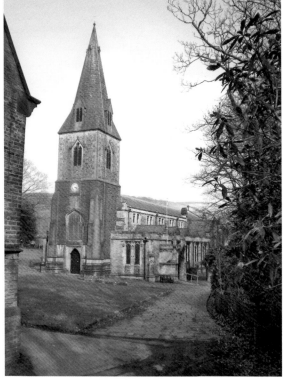

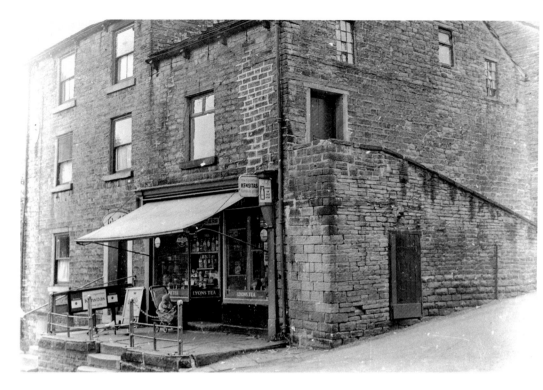

Shop at 'Town End'

The shop with its steps, raised paving and railings at the end of Thorpe Street, or Town End, will be remembered by many older Glossopians, if only for the chance of getting a Wall's ice cream on a family walk to Mossy Lea or the park. The shop and the house next to it were demolished and replaced by the Manor Stores which was later converted into a house.

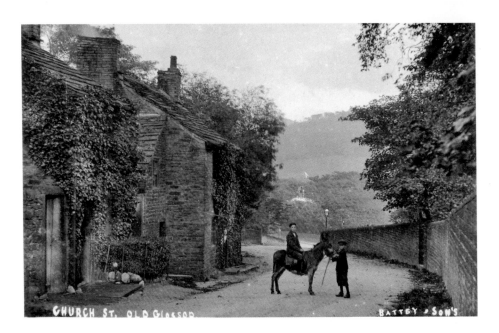

Old Cottages, Church Street, Old Glossop

Once this was the road from Old Glossop to Hadfield over the Heath, until the Turnpike of Woodhead Road superseded it. The toll bar, built in front of the Smithy, cut the old route off. The wall on the right was the boundary of Glossop Hall and the gate led to the coachman's house. In the early 1860s Cotton Famine, an old path past the hall was deepened and made into Hall Meadow Road. The Accrington brick houses were later built inside the old wall.

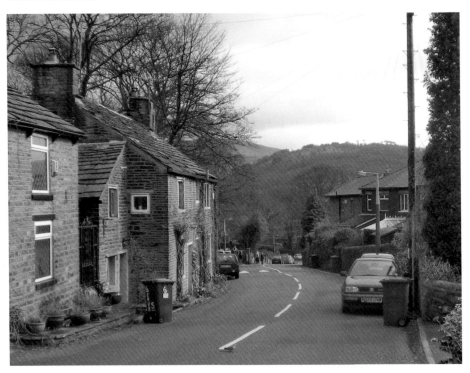

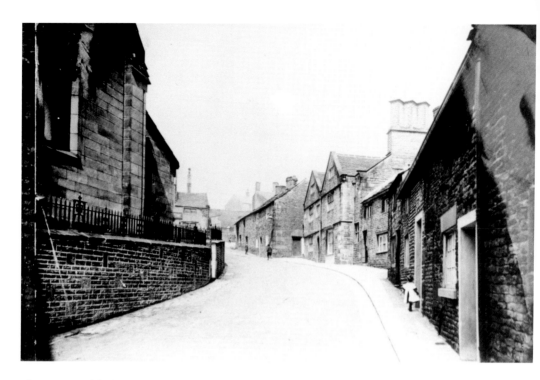

The Street, Old Glossop

The buildings at the top are here seen again, but in original form. Some earlier photographs show the pavement by the house did not exist and large stones projecting into the road shielded the house doors. Just visible to the right is a blocked doorway, reputedly the old Grammar School entrance. The rebuilt, enlarged, chancel at the east end of the church seen here was opened in 1924.

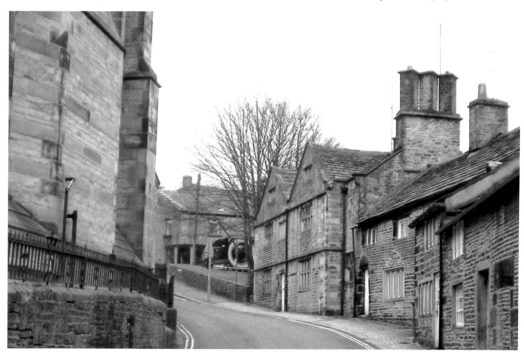

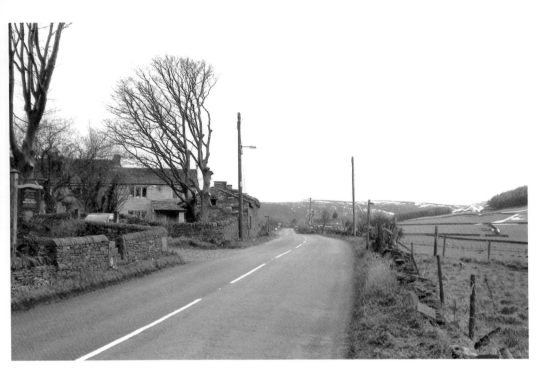

Alman's Heath Farm, Woodhead Road

Alman's Heath farm is mentioned in old legends of Glossopdale and in the descriptions of the track of the turnpike road to Enterclough (near Crowden in Longdendale) and as the home of Abraham Broadbent, one of the area's early millowners. It is now a bed & breakfast venue catering for the tourist trade and possesses some wonderful views over Peak Naze, Blackshaw and the moors to the west.

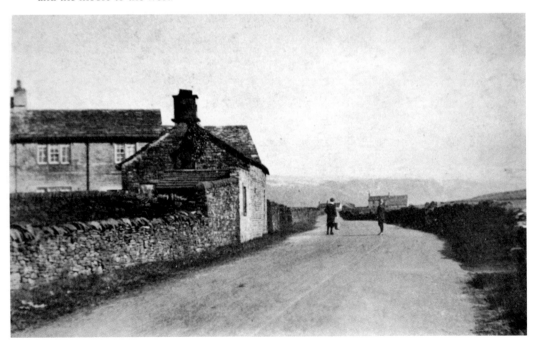

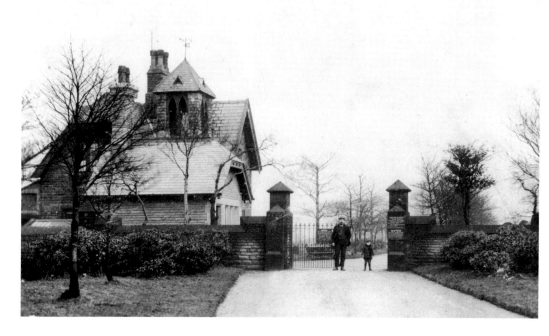

Glossop Cemetery Entrance

Today the pillars and gates at the end of the drive are missing and the building inside the gateway has been extended. On the right of the drive the cemetery grounds have been extended with an additional graveyard. Another old photograph shows the cemetery keeper and his family who lived in the building and it is captioned 'John Pym's garden'.

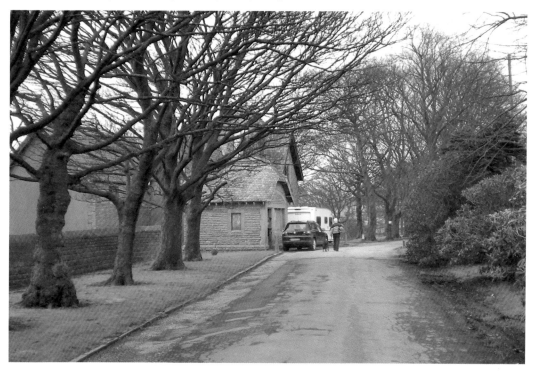

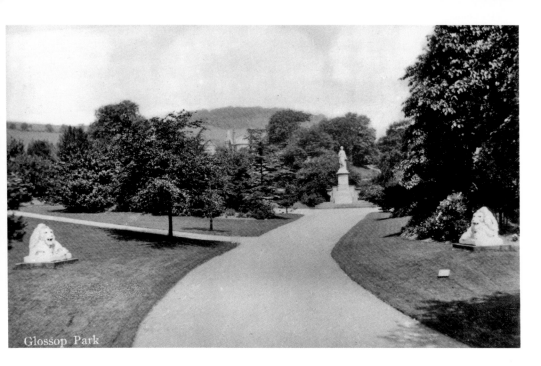

Glossop Park

Howard Park, Dinting Road

Called Howard Park, as the 12 acres of land were donated by Lord Howard, it was briefly named Victoria Park and Wood's Park after its opening in July 1887 by members of its benefactors, the Wood family, during part of the celebration of Victoria's Jubilee. They also donated the baths and the hospital which had foundation-stone laying ceremonies at the same time. The lions were often photographed with small children from that time on, but in recent times have been concealed by shrubbery.

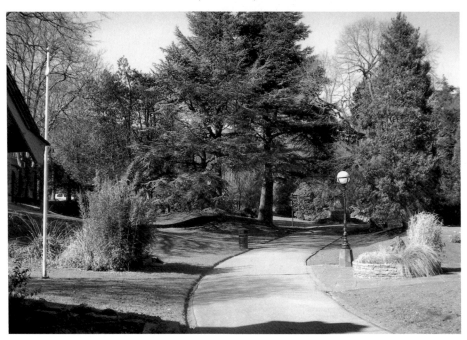

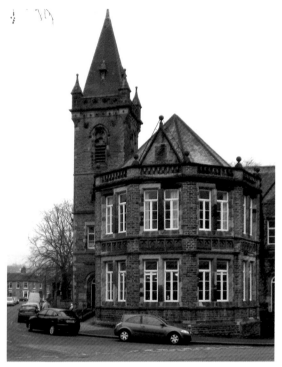

The Victoria Hall and Public Library
The library was a gift to the town from Mr Herbert Rhodes and Captain Edward Partington, the foundation stones being laid on 30 July 1887, Queen Victoria's Golden Jubilee. The history of the donation and the building of 'The Vic' were complicated by arguments and a lack of initial interest by Glossop Council. Its subsequent use by many organisations has often been contentious. Apart from the loss of the off-licence in the background, not much appears to have changed.

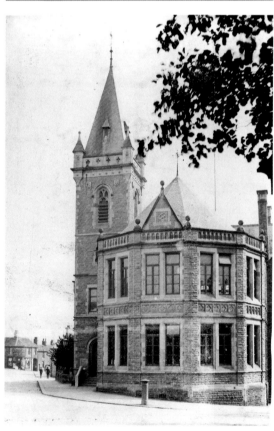

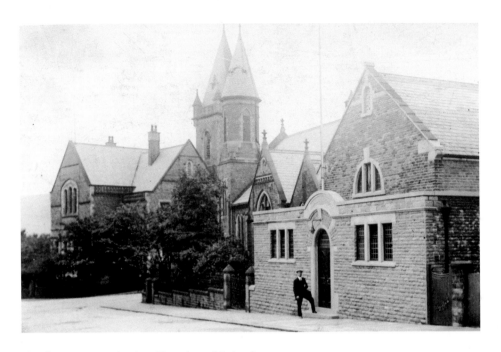

Fitzalan Street Unitarian Church and School

The old photograph shows the new front on the Fitzalan Street School which served as a memorial to the five men of the congregation who died in the First World War. The curved memorial stone from above the door is now built into the reduced front wall of the home it has become. The original high wall and wrought iron railing can be seen round the Unitarian Church and the library on the opposite side of Talbot Street.

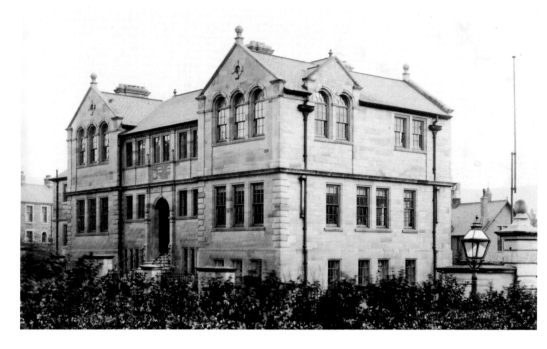

Glossop Technical School, Talbot Street, Glossop

The school, opened in 1901, was donated by Lord Howard to instruct the boys and girls of the town in technical subjects including skills in the cotton industry, and domestic science. It later became Glossop Secondary School but during the First World War it became Glossop Grammar School and was used by 'GGS' until 1959. In the early 1960s it became Glossop Adult Education Centre.

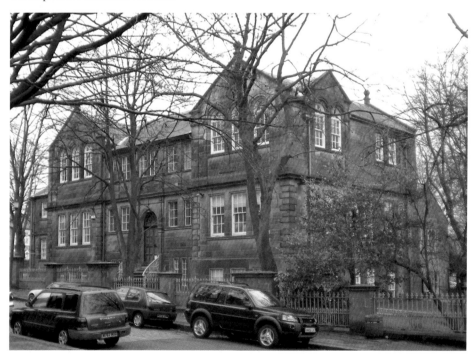

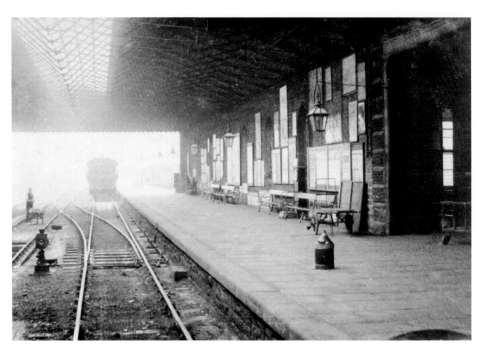

Glossop Railway Station Booking Office
Much of the station has been altered over the years. Here the full roof to the goods warehouse on the left is in place, but in the 2012 view the extended Co-op supermarket has expanded from its former home in the warehouse and across all of the tracks. The platform is now bounded by the old north wall of the warehouse, in its new position and the booking office has been moved further up the platform.

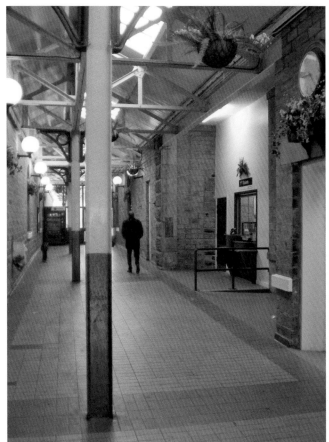

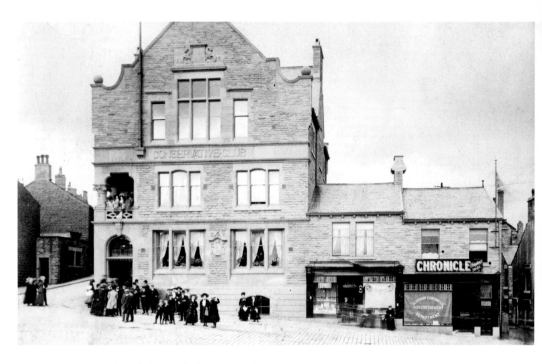

Glossop Conservative Club, Norfolk Street, Glossop

The Conservative Club, with '1909' on the stone at the top of the gable, was built on the site of the Railway Inn where the Conservative Association previously met. This old photograph is reputed to have been taken at the opening in 1910. The photograph also shows that the shop on the right, then a tobacconist and sweetshop, seems to have hardly changed at all. The next shop later became F. G. Ellis, printer and stationer.

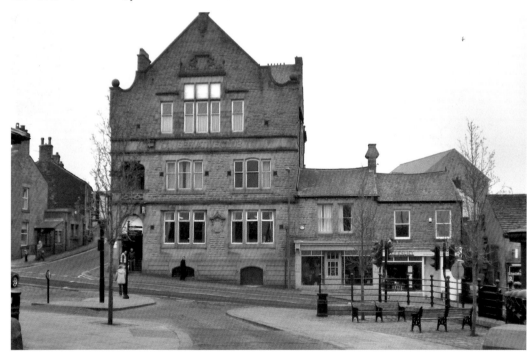

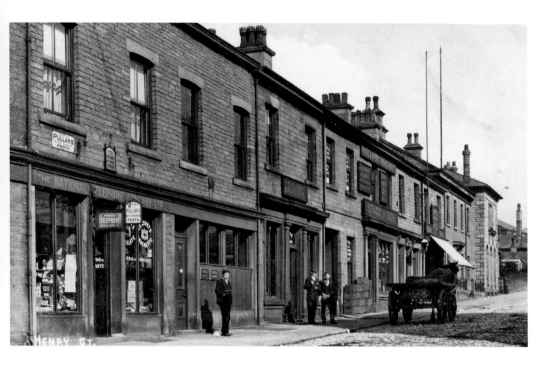

Henry Street, Glossop

The old photograph must be from a period before 1909 as the Conservative Club isn't dominating the skyline of Norfolk Street as it does today. Bank House has a low wall, gate and fence where there is now an open pavement. The National Telephone Co., Stagg & Son, Wine and Spirit Merchants, and the Co-op are amongst the businesses occupying the shops on the north side.

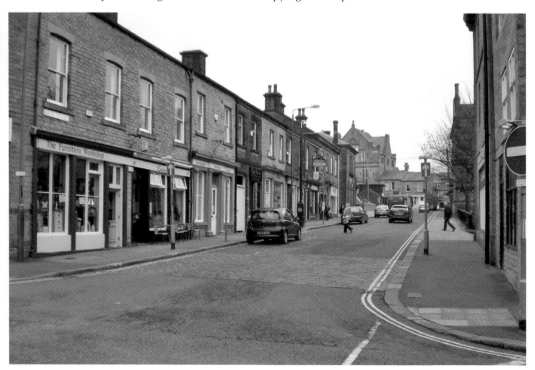

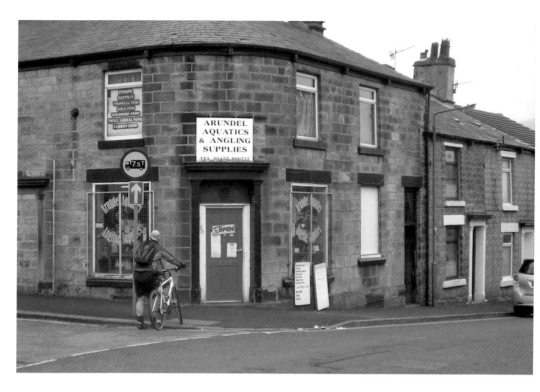

Arundel Street Co-op, Glossop

Apart from a change of use, this image of one of the many Glossopdale Co-operative Society branches to be found throughout the borough shows few real changes, apart from the loss of the gas lamp, and the tarmac coating concealing the granite cobblestones buried beneath it.

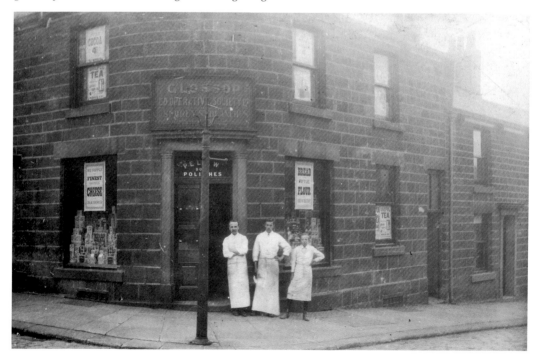

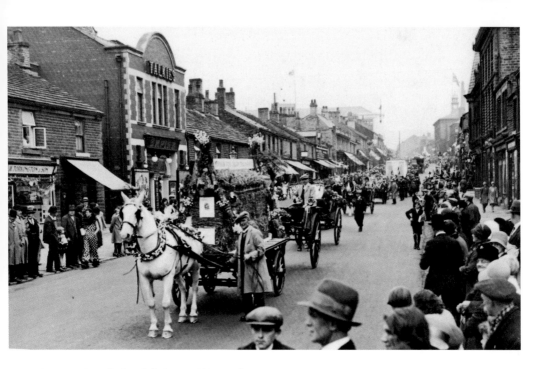

A Horse Parade in High Street West, Glossop

The view of High Street West behind this photograph of one of Glossop's Horse Parades has changed more than most of the street. The Empire Cinema and shops to the east have been replaced with 1960s brick structures and the older stone, former 'Co-op Café', block.

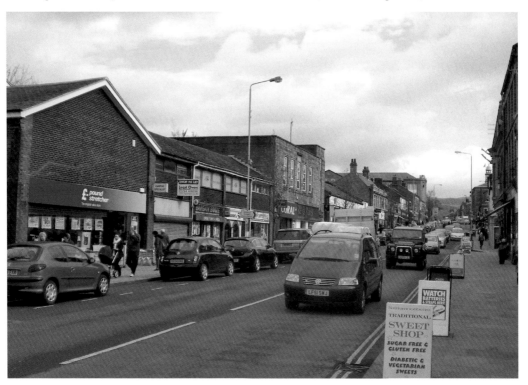

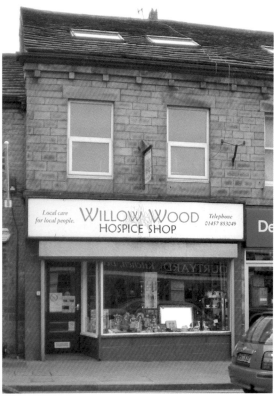

Matthew Woodcock's Shop
This photograph of a proud Glossop shopkeeper and his family was taken in 1902 and was sent to one of the authors from Denmark by a descendant of a Glossop family who had businesses in the High Street at the turn of the twentieth century. The quality of the original, one of several sent at the time, is such that it can be enlarged to a huge size and the smallest text in the window can be read.

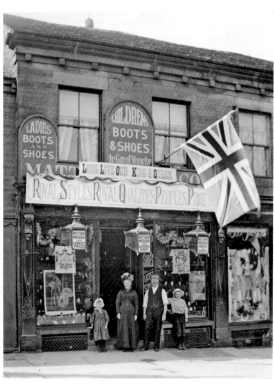

Dearnaley's Grocer's Shop

The shop on the corner of Market Street during a September 'Old Wakes' week has an incredible collection of tinned food and unwrapped sides of bacon on display. The roundabouts on the Wakes' Week Fair on the Market Ground can be seen through the side window, as can the photographer in the door glass. After many years as a shoe shop the site now sells food again.

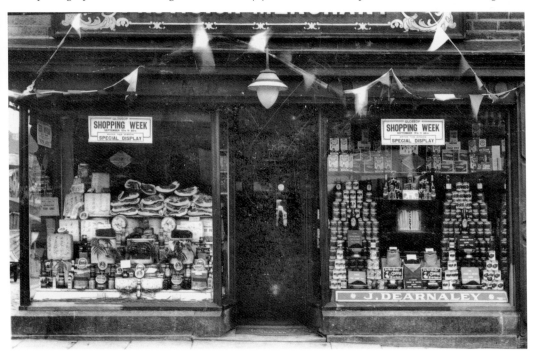

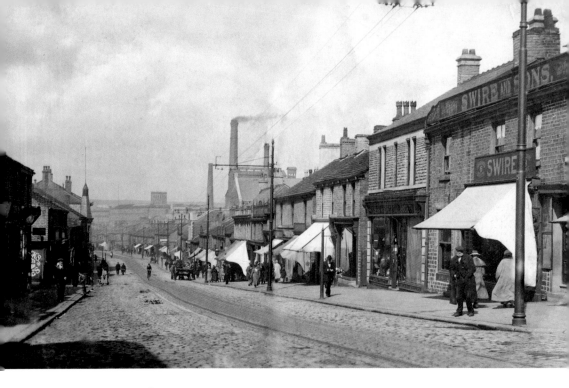

High Street West, Glossop, *c.* 1922

Apart from obvious modern changes the most notable absence amongst the Glossop landmarks is the Glossop Gasworks, which stood in the land between Arundel Street and Shrewsbury Street and was more than just a visible presence, depending on which way the wind was blowing. Today only a few canvas awnings project over the pavement and the windows of the high street shops.

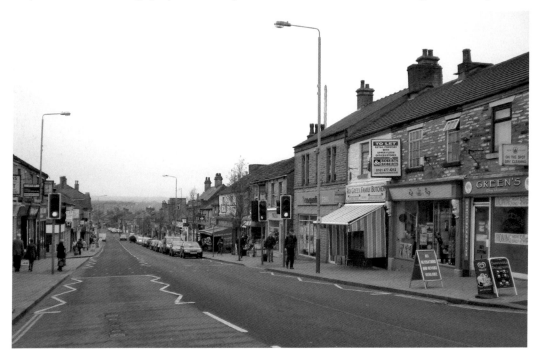

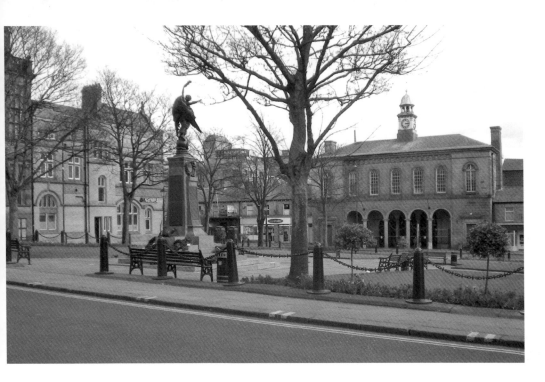

Norfolk Square and the Town Centre War Memorial, Glossop
The view from Henry Street, as seen here, featured as a line drawing in the *Glossop Chronicle* for many years, heading the 'Watchman' column which covered most of the interesting, or even contentious, events in the town. The recent view still has the Remembrance Day wreaths in place in April 2012 while the older, sunny, summer evening one still lacks the Second World War plaques.

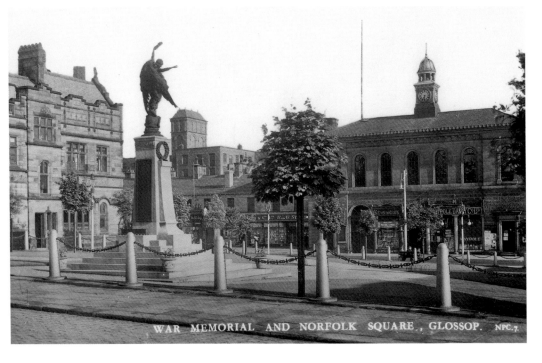

WAR MEMORIAL AND NORFOLK SQUARE., GLOSSOP. NPC.7.

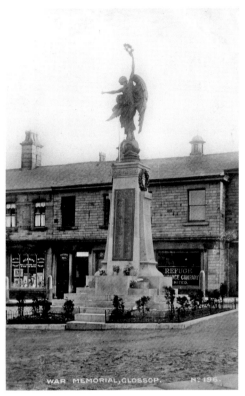

WAR MEMORIAL, GLOSSOP. Nº 196.

The War Memorial, Glossop
When first dedicated after the First World
War, the memorial was surrounded by a
garden which was later replaced by an
extension of the steps on which wreaths
were placed during the annual Remembrance
Day service. The Henry Street buildings in
the background still include the Devonshire
Masonic Lodge which was refurbished
c. 2008/09.

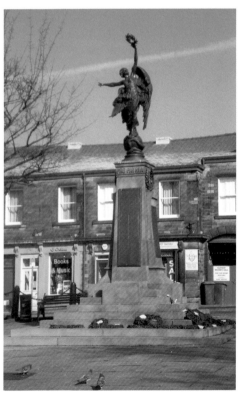

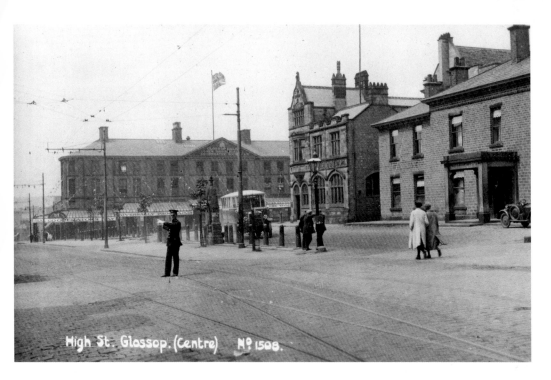

High St. Glossop. (Centre) Nº 1508.

The Norfolk Arms, Bank and Co-operative Society, High Street West
Before the advent of the traffic lights at the crossroads, as many old photographs show, traffic was regulated by a policeman on point duty. The Norfolk Arms built as The Tontine, *c.* 1822, and the bank look much the same, apart from the pub's enclosed porch, but the forecourt is no longer the bus station. The 1930 frontage modernised the Co-op south front and the arcading disappeared. The tram lines still occasionally appear during roadworks.

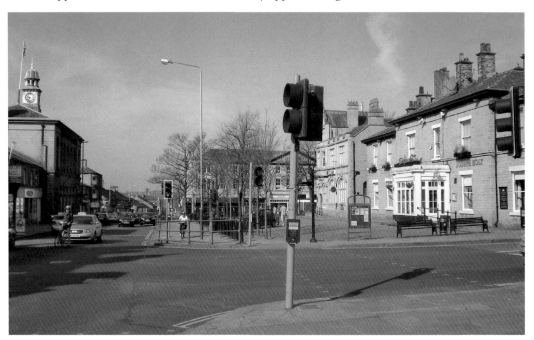

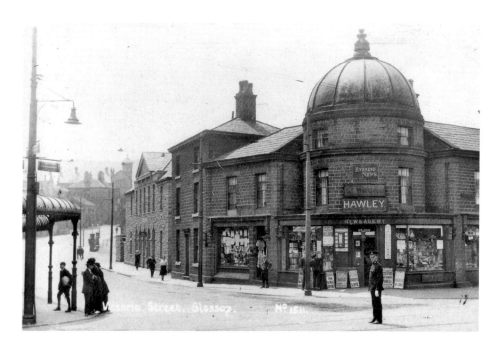

The 'Dome'

The site at No. 1 High Street West has undergone many changes since it was built as a domed tower on the west end of the main architectural feature of the new town of Glossop, designed by Weightman & Hadfield for the Duke of Norfolk. It has been a chemist and a newsagent and then in 1937 it was demolished to become Burton's tailors, and later rebuilt as a bank.

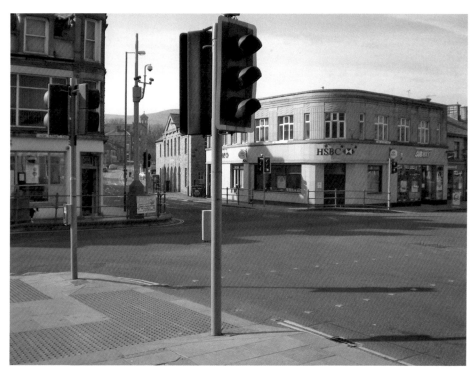

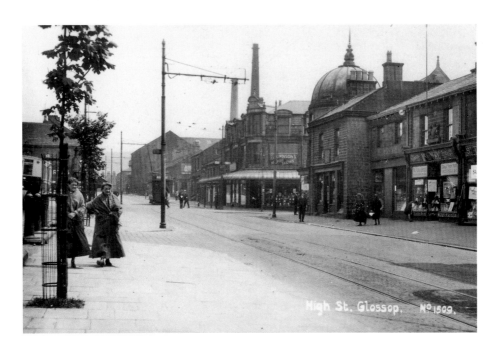

'Brownson's Corner' to 'Woolies'

Although the 'Brownson's Corner' arcade has long gone, the main architectural features of the building remain, but Wood's 'Fireproof Mill' and chimneys no longer fill the background. To the west and nearer the viewer, Burtons' 1937 rebuilding changed the frontage of No. 3 High Street West forever. No. 7 High Street West still remains the same, at least for now. In the old view T. P. Hunters is still in the building most Glossopians still remember as Woolworths.

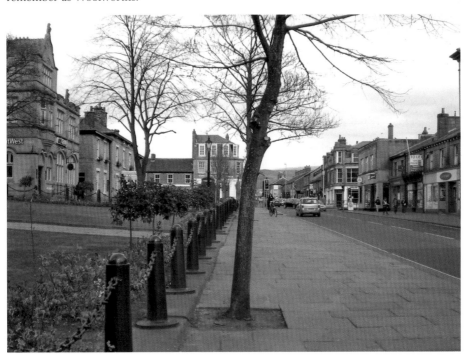

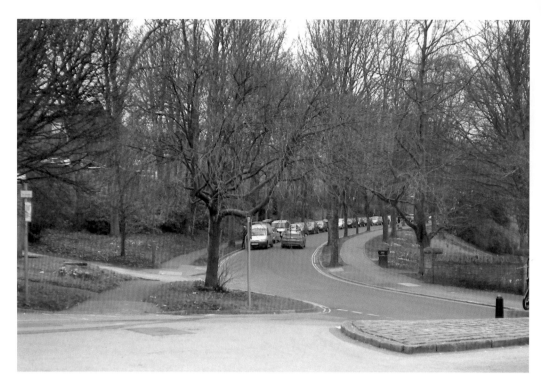

Philip Howard Road from the Market Ground

This older view of the bottom end of the road was taken just before Christmas in the early 1960s by one of the authors and illustrates how the tree cover has grown over the road since that time. Just visible in the background is one of the rustic shelters provided by Mr Farnsworth, a former mayor of the town in the 1930s. The original flowerbeds and seats bordering the road looked out over the town centre towards Mouselow.

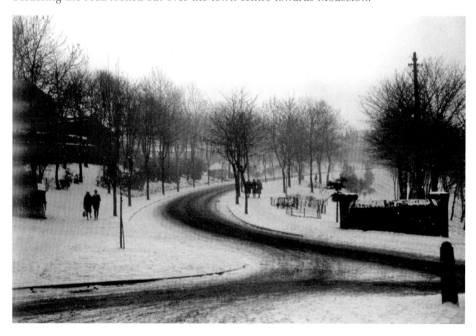

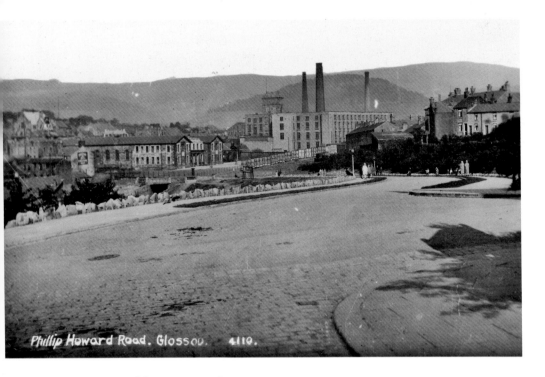

Phillip Howard Road. Glossop. 4110.

Philip Howard Road from Mount Pleasant

Philip Howard Road was built as a memorial to Lt Philip Howard, Commander of No. 3 Company, 1st Battalion of the Welsh Guards, who died of wounds received in action on 24 May 1918 and also the other men of the town who lost their lives in the First World War. The area had previously been allotments running down from 'Top Sandhole' to the Glossop brook. Today the scene is quite different as the trees obscure most of the view.

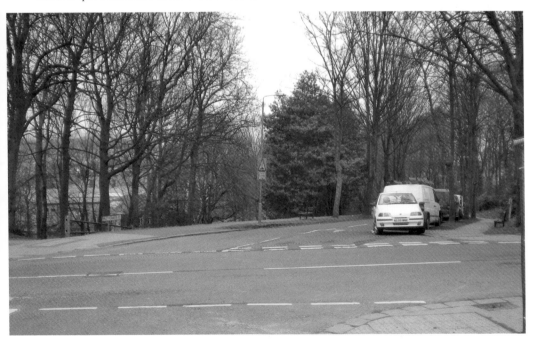

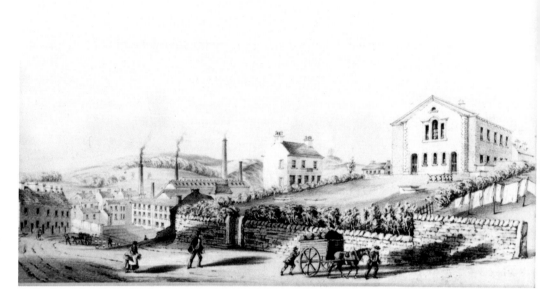

The Little Moor and John Wood's Howardtown Mills

This engraving of the south of the area called Littlemoor was made before the later school (now obscuring the view of the Chapel) was built on Victoria Street, and also shows Chapel House on Gladstone Street and the earlier school on King Street. Wood's Mill wall in the distance by the bridge still exists but Shivering Row on the left is the site of the telephone exchange.

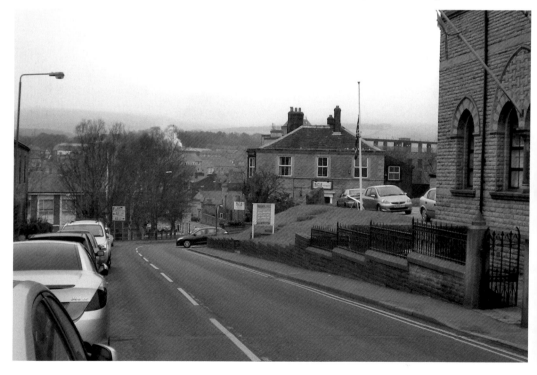

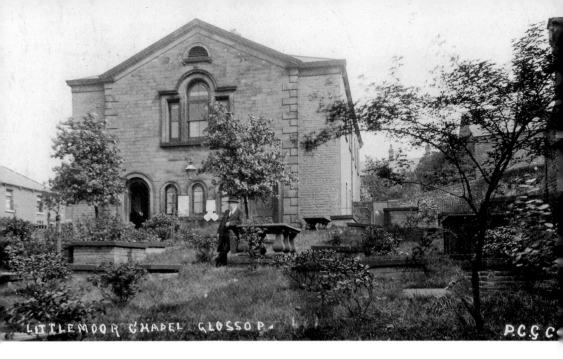

Littlemoor Chapel, Victoria Street, Glossop

The chapel, built in 1811, had quite an extensive graveyard in front of it, and is now the car park for the Bodycheck Health Club. When Littlemoor Chapel closed the graves in front were removed to Glossop Cemetery. Chapel House was built in 1847.

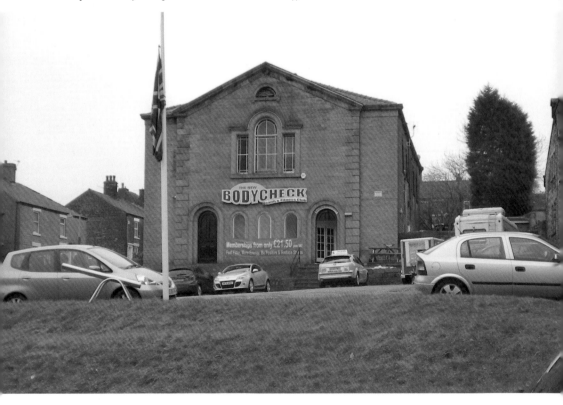

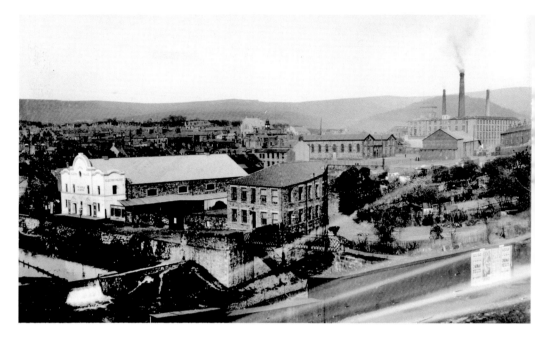

The Palace Theatre, the Glove Works and the 'Sandhole'

Here the Palace Theatre has become the Electric Palace, the Gloveworks stands on part of the old Ironworks site and the 'Sandhole' still has its allotments. Close inspection shows that there is no concrete bridge on the end of Market Street and no Philip Howard Road. The Theatre Royal stands on the south of the Market Ground and the Municipal Buildings are still the covered markets and an open fish market. In the modern view, little of the changes can be seen.

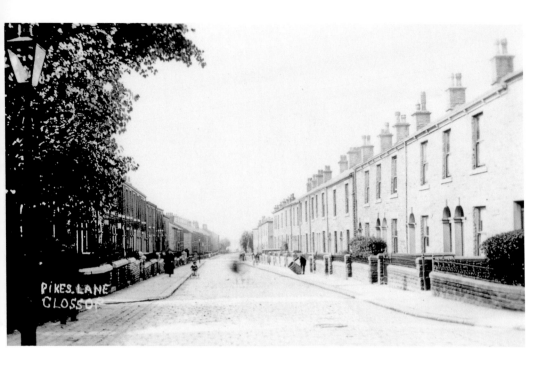

Pikes Lane, Glossop

Apart from minor modern additions and the covered cobbled road surface, little difference can be seen in the photographs. The on-road parking shows that Glossop, with its rows of terraced houses, was not built with car ownership in mind. Traversing the road from either end is often difficult and an issue for public service vehicles and lorries. Robert Hamnett, writing in the early twentieth century, says in 1871 that it was a 'cow lane' to Pikes Farm.

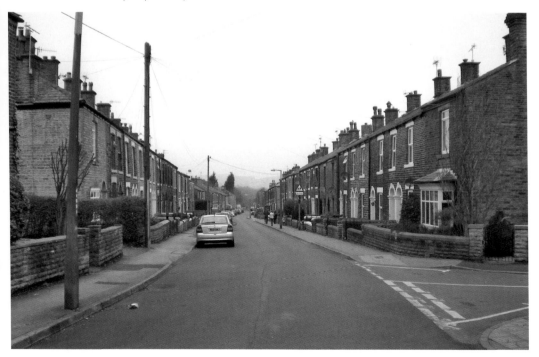

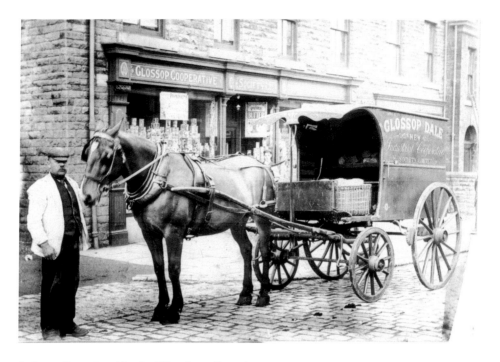

A Co-op Cart, Outside the Pikes Lane Branch

The Pikes Lane branch, opposite Princess Street, was just one of the many now vanished Co-op shops to be found throughout Glossopdale 100 years ago. The photograph seems to be one of the few which has left us an image of the staff and transport arrangements from our grandparents' time.

Whitfield Drinking Fountain

In the days before the motor vehicle the streets were full of horse-drawn carts and wagons so drinking troughs and fountains were provided to supply water for the horses and also supposedly for the carters, to prevent them partaking of anything stronger while at work. Mrs Anne Kershaw Wood provided several in the town. Some troughs even had water supplied at dog level. This one at the junction with James Street doubled as a lamppost.

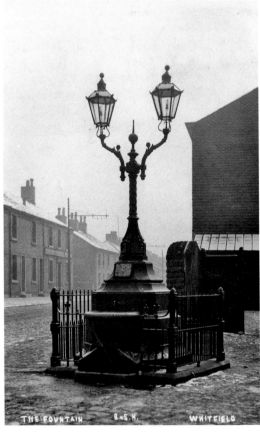

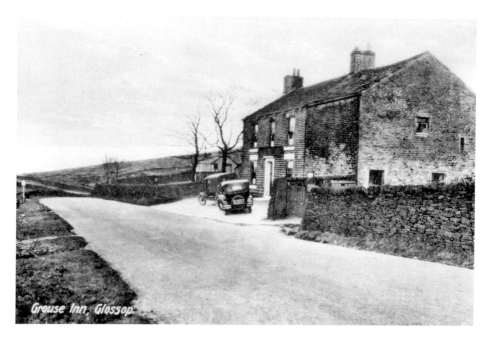

The Grouse Inn

The Grouse Inn was built by Abraham Rowbottom, a son of Moses, a Chisworth farmer. Weather permitting it has a beautiful view over the town and has long been a popular stop for motorists. Recently it has been the take-off point for helicopter flights which give an even better view over the local landscape. Comparison with older images shows how it has been extended into the barn structure.

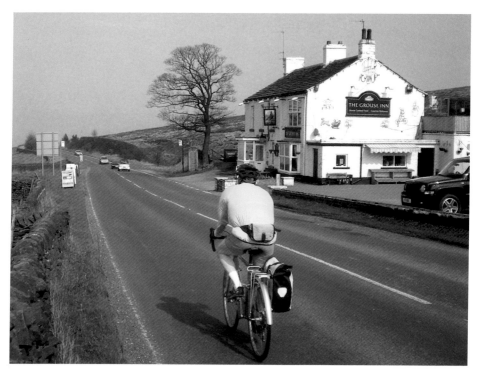

Monks Road

It seems little has changed on this moorland route, part of the old road from Charlesworth and Simmondley southwards to Hayfield, Chapel-en-le-Frith and Buxton. Legend has it that it was built by the monks of Basingwerk Abbey but most probably some of the route follows the old Roman road from Melandra Castle towards Buxton.

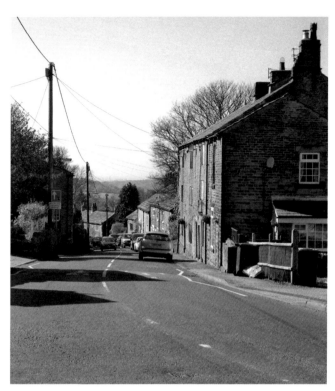

Town Lane, Charlesworth
A lovely photograph of a quiet country lane taken looking towards the village. Today the view, the telegraph poles and the shadows remain the same although most residents now have cars parked outside their homes which have the effect of slowing down commuters on this busy route.

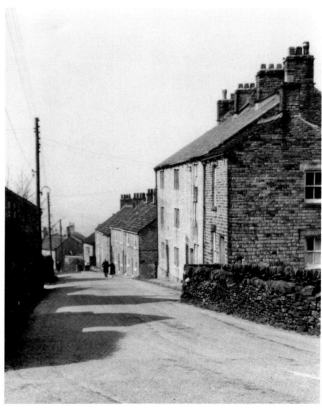

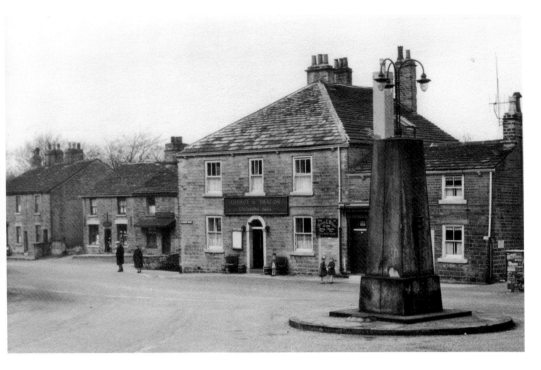

Village Centre and the George & Dragon, Charlesworth

Another virtually unchanged view of the George & Dragon and the village war memorial. The war memorial has lost its lighting arrangement and gained bollards for safety. The war memorial in Charlesworth is always beautifully presented and well adorned with remembrance wreaths.

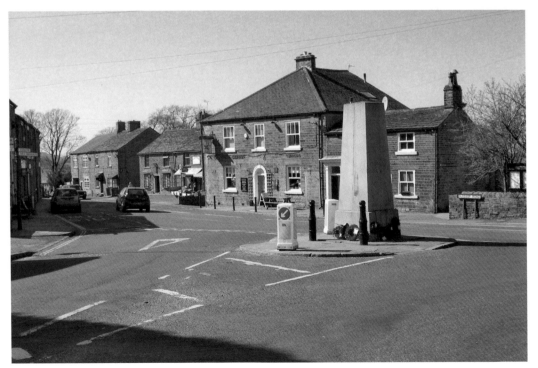

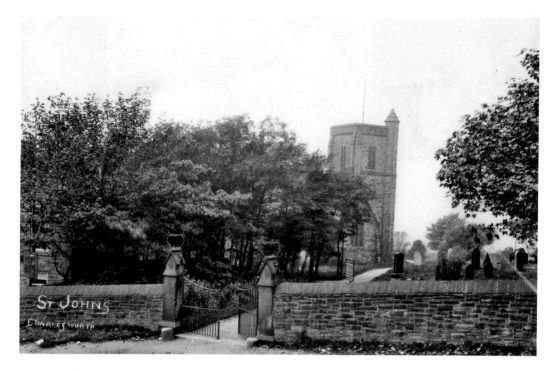

St Johns Church, Charlesworth

St John the Evangelist church was built in 1848 and consecrated on 8 October 1849 by the Bishop of Lichfield. The nearby school opened in 1851 on a piece of land purchased for £60. Today the church and its grounds are a credit to the village – both are well maintained, looked after and loved.

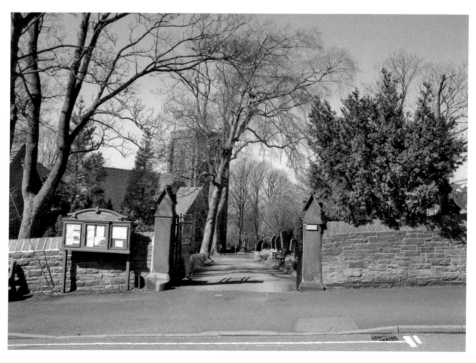

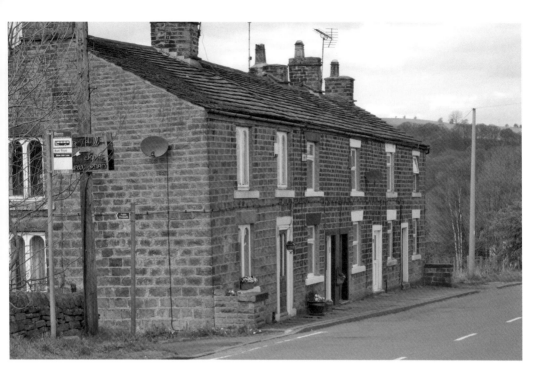

Long Lane, Charlesworth

A nice sepia postcard, *c.* 1915, shows the residents at their doors posing for the photographer. The first cottage in the foreground appears to have been built later than the other four. A quick check on the 1911 census gives a clue that these cottages were occupied by two widows and three married couples with families.

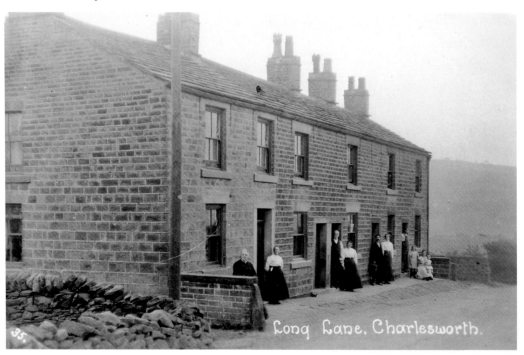

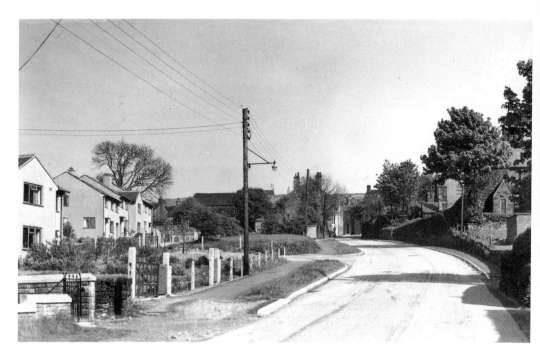

Long Lane, Charlesworth

A slightly more recent photograph, *c.* 1950s, shows fairly newly built houses at the top of Long Lane with its junction with Church Fold and in the far distance the junction with Marple Road. The gardens in front of the houses have matured and hence the modern view is obscured. The layout of the lane is the same but these days it is a busy commuter route.

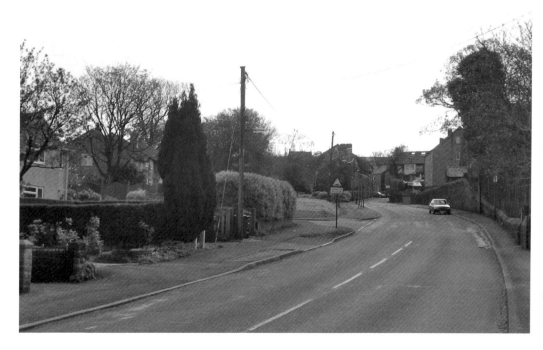

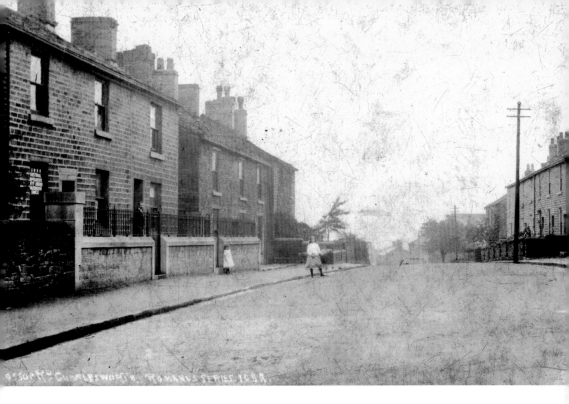

The Post Office, Charlesworth

Glossop Road, Charlesworth looking towards Gamesley. The village post office sits at the end of the row adjacent to the George & Dragon pub car park and opposite the Grey Mare Inn. The road is often heavily congested with commuter traffic passing through.

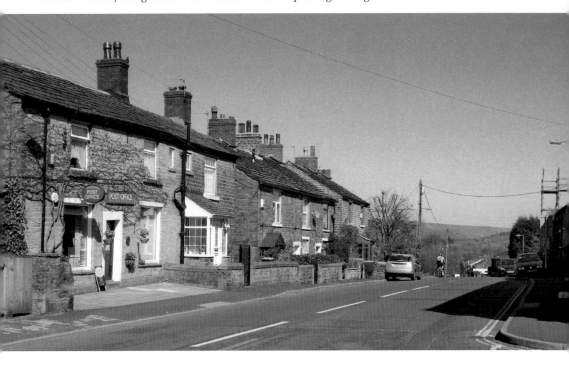

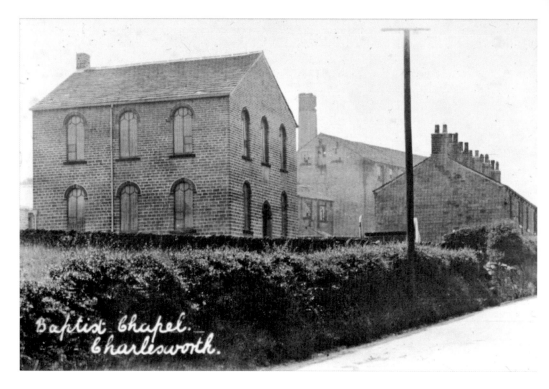

Baptist Chapel, Charlesworth

Charlesworth boasts four places of worship. The Baptist Chapel on Glossop Road has recently undergone extensive renovations and today looks as good as new. In the older photograph the chimney and part of a former cotton mill can be seen in the background. Charlesworth Mill was built around 1825, about the same time as the Baptist Chapel. Both are shown clearly on the 1857 Poor Law Map.

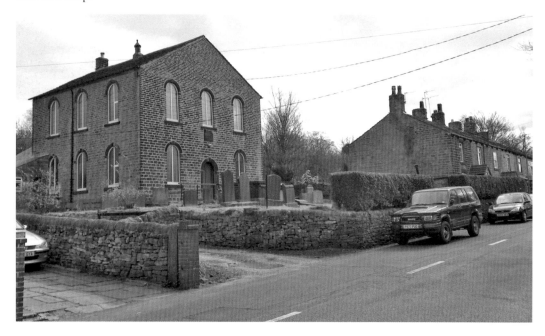

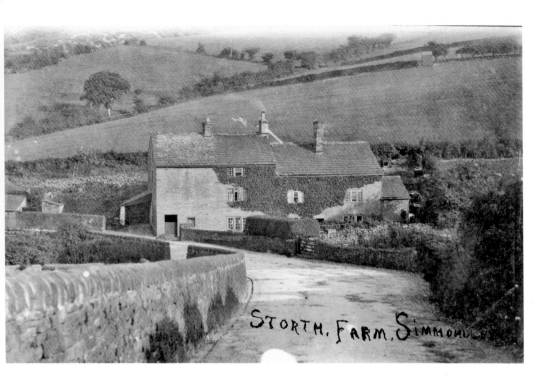

Storth Farm, Simmondley

A beautiful view of rural Simmondley. The Nab behind the farm remains unchanged but the farm buildings have been sympathetically altered and added to over time. The road is now a busy commuter route for residents of Simmondley travelling into Greater Manchester.

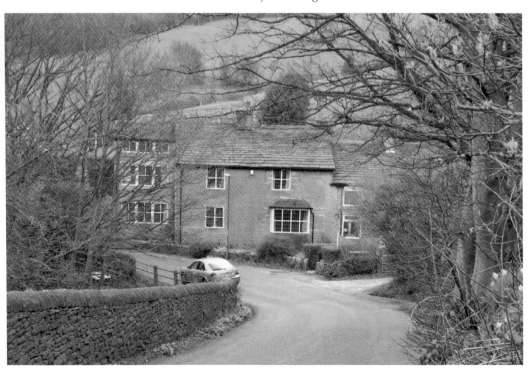

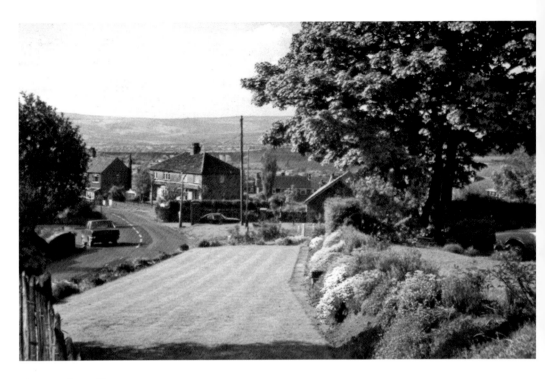

Simmondley Village

An older coloured postcard, *c.* 1970s, shows a view over a beautifully manicured lawn at Fickle Springs. The view is impossible to replicate today due to a high hedge. The red telephone kiosk is still in use today and adds cheerful colour to the composition.

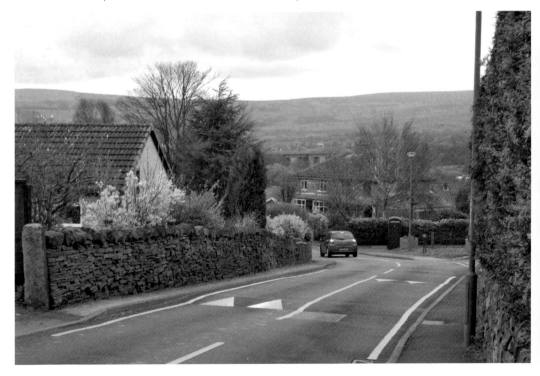

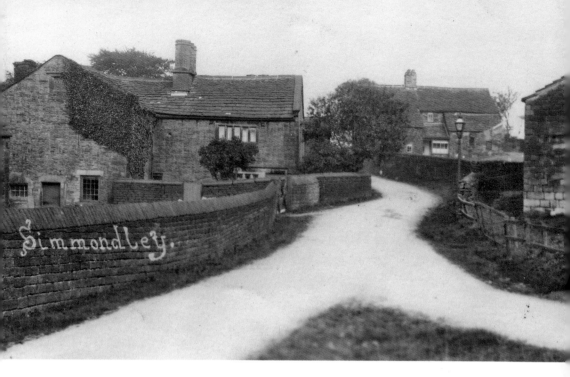

Simmondley Village

Old Cottages in Simmondley Village. This view looks east towards what is now Simmondley New Road from the Green. The carriageway and most of the old buildings are almost the same today.

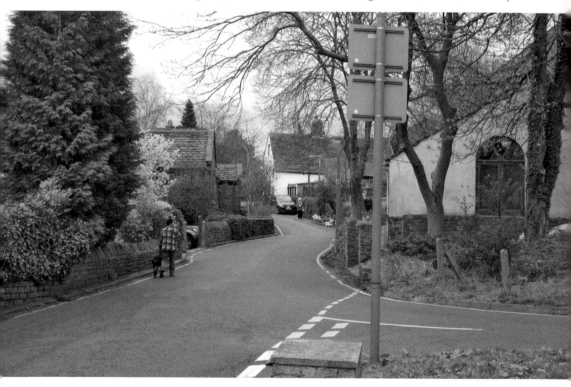

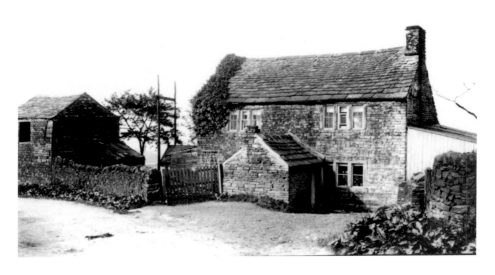

Old Cottages, Simmondley

A rare and unbelievably old photograph of what was probably a farmhouse and outbuildings. The buildings no longer exist but were situated where this nice pair of semis now stands on Simmondley Lane looking north from the Green.

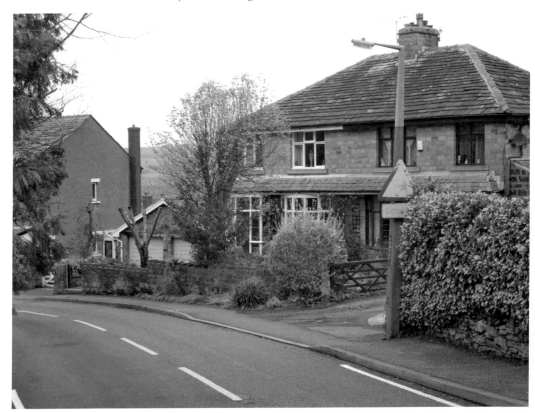

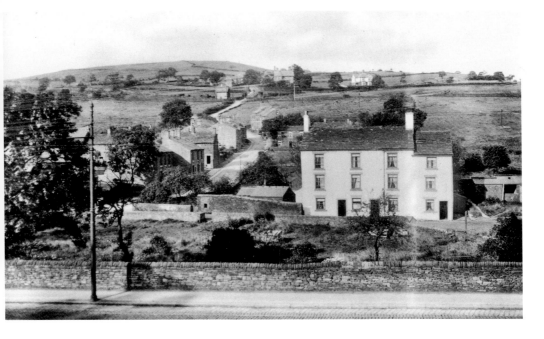

Dinting Lane

Dinting Lane, Glossop, viewed from Adderley Road. The view today from high ground adjacent to Dinting Scout Headquarters is completely obscured by trees. Logwood Mill, which would be just off the old photograph to the east and its cottages were demolished long ago and the site is now occupied by Lancashire Chemicals Industry. Dinting Road is just visible to the top of both photographs.

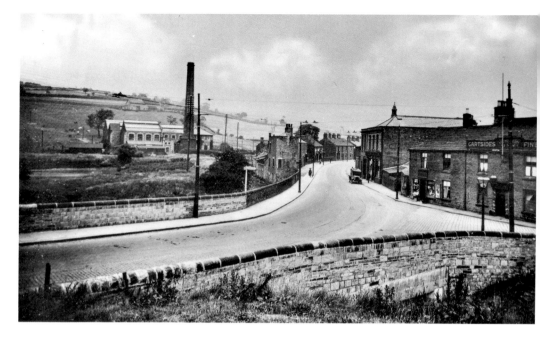

Junction Inn, Glossop

The former Junction Inn on High Street West at its junction with Primrose Lane viewed looking towards the town centre. The older photograph clearly shows the former tram depot and Urban Electricity Supply Company buildings. Today the Junction Inn building has been renovated and is currently in use as an estate agency. The old Co-op shops have been demolished and new housing replaces them. The road junction now has a plethora of traffic signs.

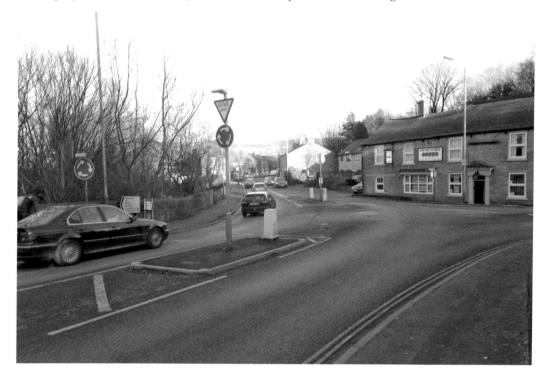

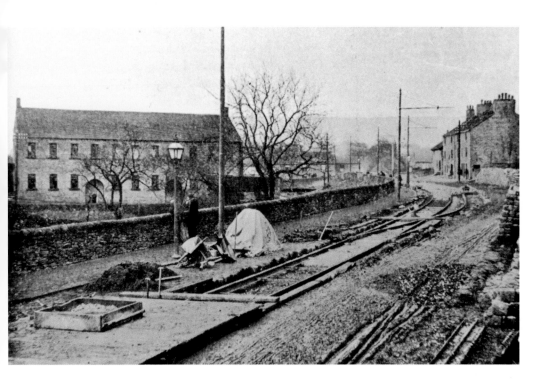

High Street West and Dinting Vale Tram Works

The old photograph taken *c.* 1902 shows Logwood Mill clearly on the left and a view east along the start of High Street West at its junction with Simmondley Lane when the track for the tramways were being laid. Logwood Mill, the tram track and the terrace of houses on the right have all gone. Frequent bus services to other villages and destinations have replaced the tram.

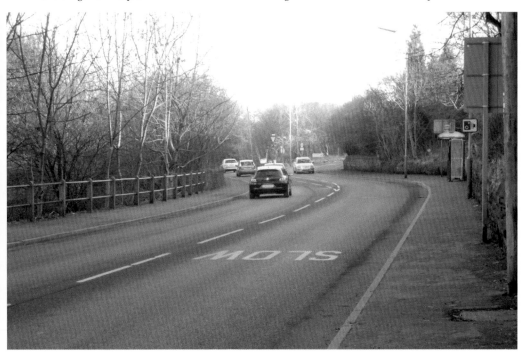

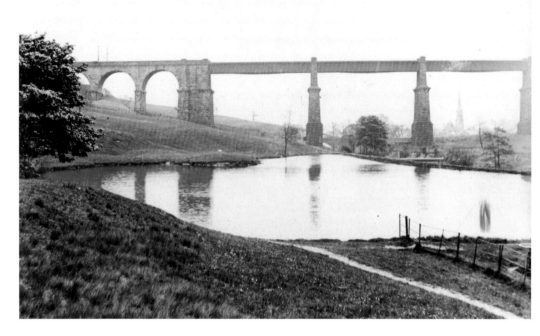

Dinting Viaduct from the West

The view of Holy Trinity Church is completely obstructed by the later addition of brick pillars to reinforce the structure. The millpond which served Dinting Vale Printworks has now become naturalised and is in regular use by members of Glossop & District Angling Society.

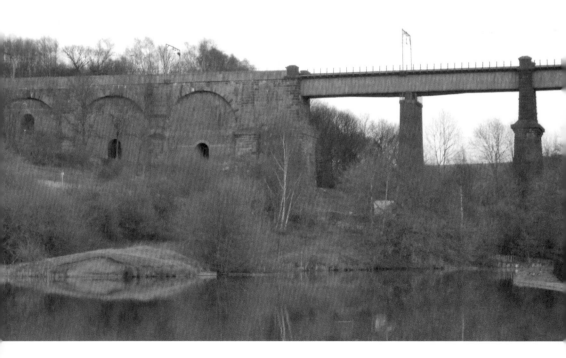

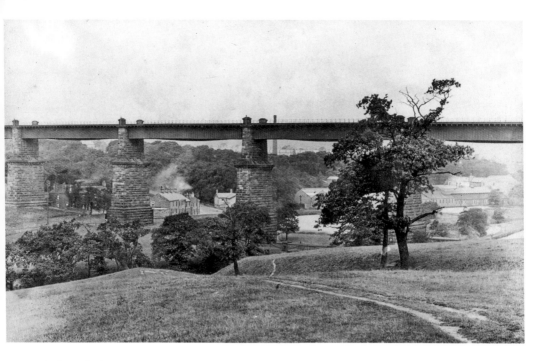

Dinting Viaduct

The original postcard is entitled Dinting Arches although it should be called Dinting Viaduct. The viaduct was opened in 1844 on the Manchester, Sheffield & Lincoln railway line and re-enforced with brick supports later. The view shows the former Plough Inn on Dinting Vale and in the foreground the track between Lower Dinting and Gamesley. The tree in the right foreground looks to be the same one in both views.

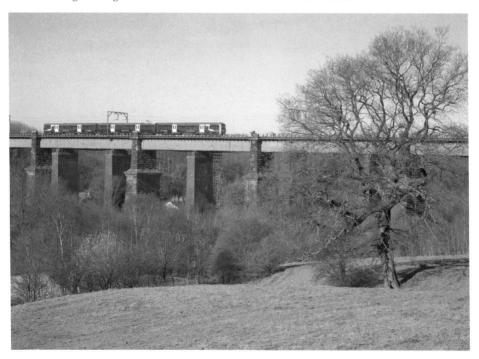

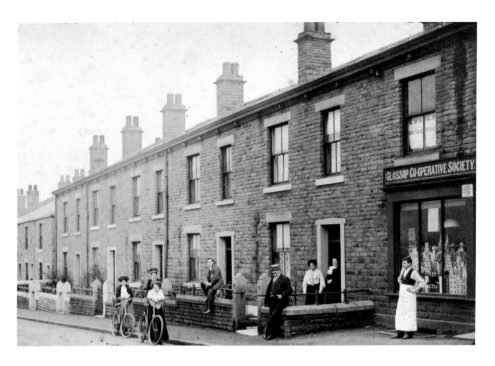

Co-op, Glossop Road, Gamesley

A fantastic old photograph of Glossop Co-operative shop on Glossop Road, Gamesley. Residents and shopkeepers are out in their finery to pose for the photographer. Today, the view is virtually the same and the shop is a thriving general store, Morgan's of Gamesley.

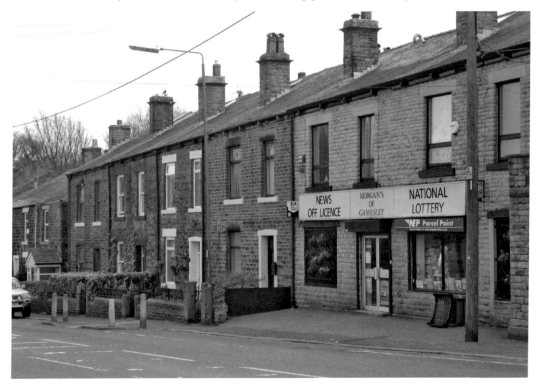

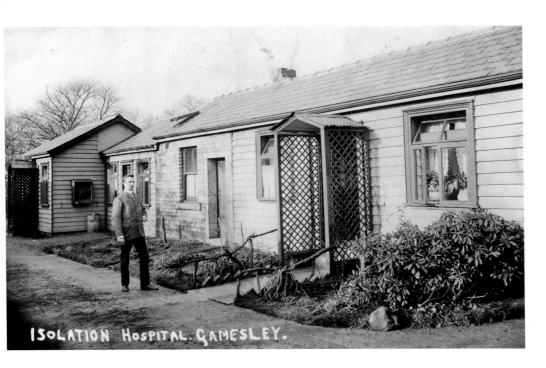

ISOLATION HOSPITAL. GAMESLEY.

Isolation Hospital, Gamesley

A rare photograph of chalets at the Isolation Hospital, Gamesley, which was located near to Robinwood Farm. Used for the treatment of infectious diseases such as scarlet fever, diphtheria and smallpox, the hospital was of a corrugated iron structure clad with wood and enclosed by a 6-foot 6-inch-high fence. It had space for ten beds but had accommodated thirty-two beds. The views from this south-east facing site must have made patients feel much better.

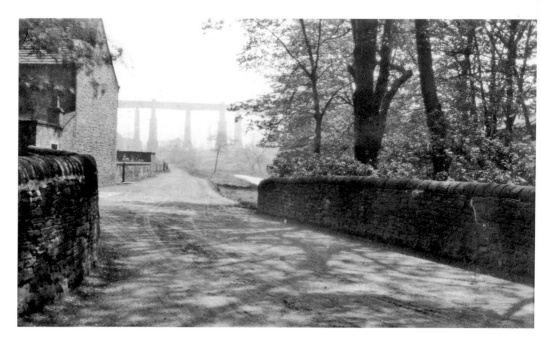

Dinting Vale Site of Potter's House and Garden

The large house with the gable end on the left of the older photograph was that of Edmund Potter (uncle of the famous author Beatrix Potter) and owner of Dinting Mill. The house has been demolished and all that is left of the original scene is a few rhododendron bushes and a view of Carpenter's factory lorry park.

Spread Eagle, Woolley Bridge

The original photograph shows a very smart and tidy Spread Eagle Hotel taken by a young photographer, Philip Battey. The pair of semi-detached houses have been demolished and in their place is a bus stop and Lawrence's barber shop. The Spread Eagle Hotel closed many years ago and awaits renovation. Philip Battey, the young man to whom the original is credited, will celebrate his 99th birthday on 12 June 2012.

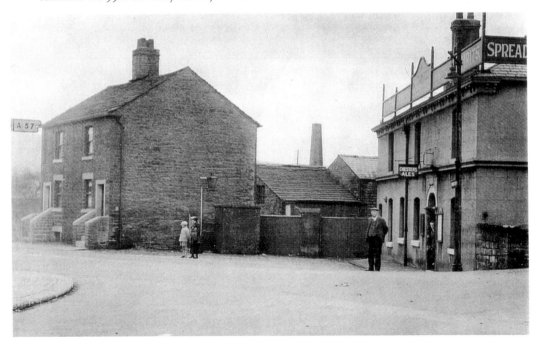

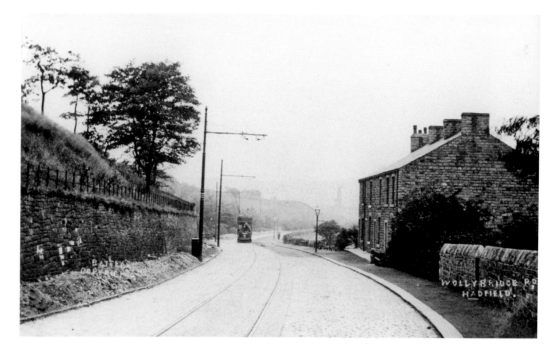

Woolley Bridge Road, Hadfield

A solo scooter rider replaces the tram in the recent photograph. The older picture is another of Battey's showing a row of cottages north-east of the entrance to Carriage Drive to St Charles church. In the 1960s there was a garage and petrol filling station near to these cottages. The cottages and garage have been demolished and a new vehicular entrance facilitates the new industrial premises.

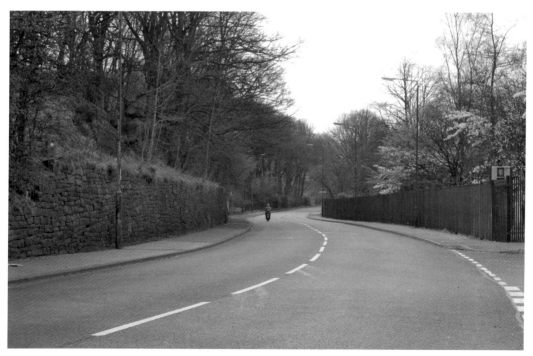

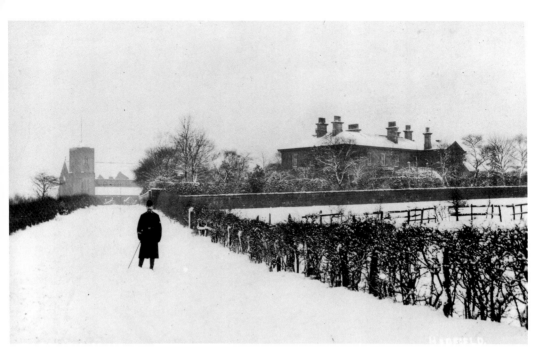

Carriage Drive, Hadfield

A lone police officer stands on the carriage drive after a heavy snowfall in the older photograph. Ironically these days there are police buildings and offices on Mersey Bank Road to the right of the picture. Traffic signs, parked cars and residential buildings dwarf the magnificent Mersey Bank House and St Charles Borromeo Roman Catholic Church, both obscured by trees.

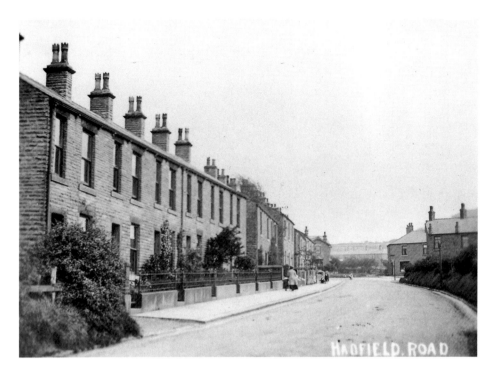

Hadfield Road, Hadfield

Hadfield Road looking up towards the junction of Green Lane and Newlands Drive. Very little has changed in this view with the exception of satellite dishes and Newlands Drive housing being built.

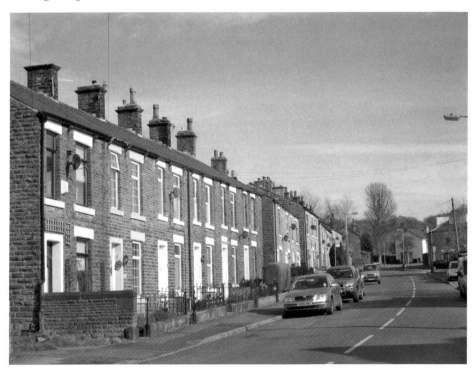

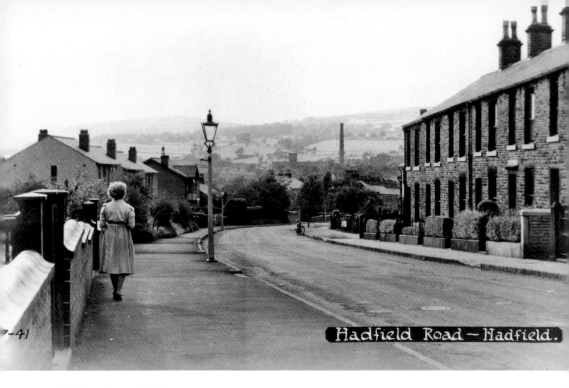

Hadfield Road, Hadfield

The older photograph was probably taken about 1960 and shows a lone pedestrian going for a stroll towards Woolley Bridge. Nowadays the view has barely altered apart from householders' parked cars.

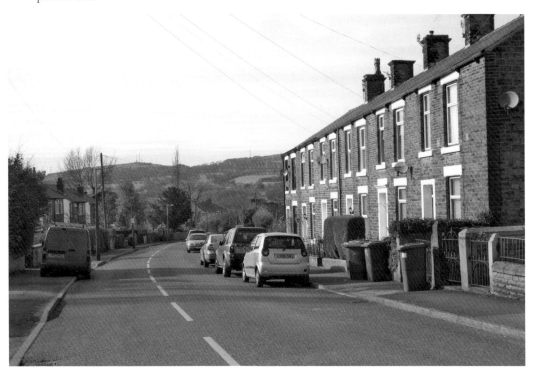

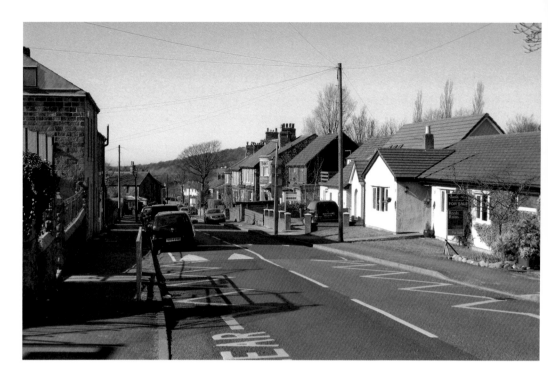

Hadfield Road, Hadfield
An old view taken *c.* 1904 from outside what is now St Andrews Junior School towards Green Lane. The new photograph shows that cottages have since been built on the left of the road and newer bungalows in the open space on the right. Beech House to the bottom of the road at its junction with Newlands Drive remains the same.

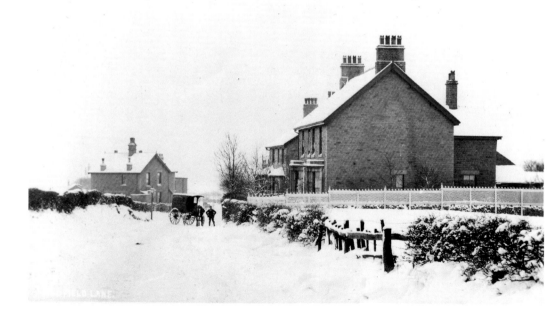

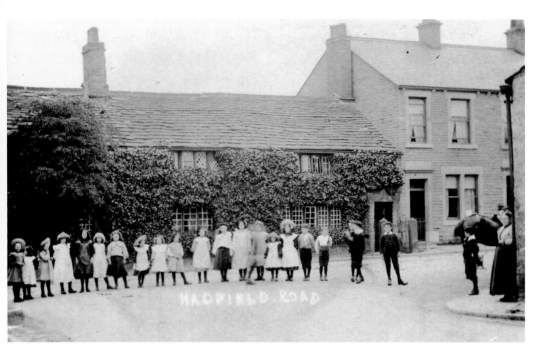

Hadfield Wesleyan Day School Scholars Outside Ivy Cottage, Hadfield

The old photograph was taken around 1910 and shows the children from the Wesleyan Day School which was situated just down the road where St Andrew's Junior School now stands. Oddly there are only six boys with the sixteen girls! The building to the right of the old picture has long since been demolished to make way for Spinney Park.

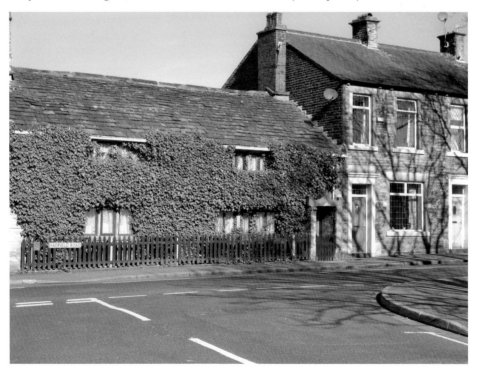

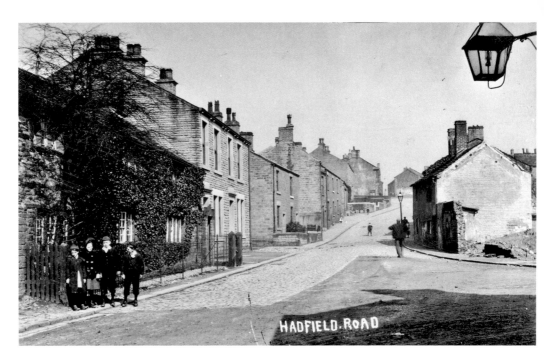

Ivy Cottage, Hadfield Road, Hadfield

Another of my favourite old postcards, *c.* 1910: a beautiful view of Ivy Cottage looking towards Old Hall Square with children in their Sunday best posing for the photographer. A section of cottages on the right has been further demolished to make way for Walker Street. Instead of old gas lamps, satellite dishes now adorn several properties.

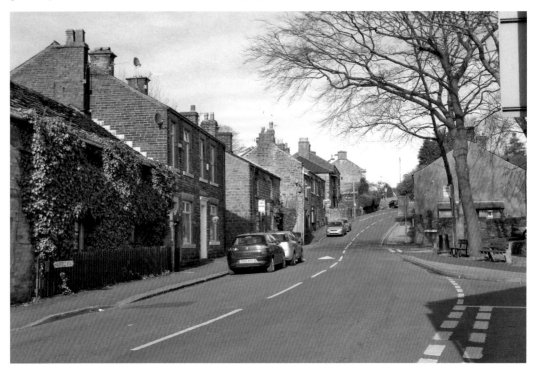

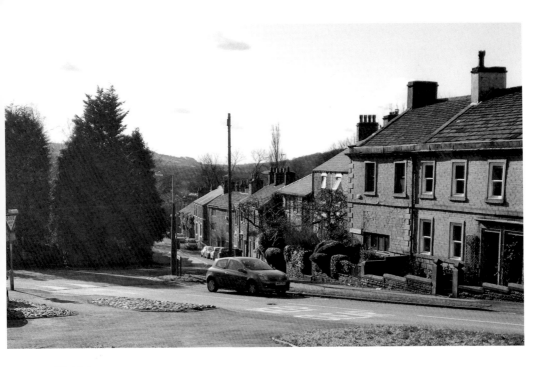

Hadfield Cross

The original photograph taken by Battey & Sons around 1914 shows the original position of the old lamppost which has been re-sited onto Old Hall Square, a neat village green. The buildings to the right have been altered slightly over the years and were originally used as the vicarage for St Andrew's church.

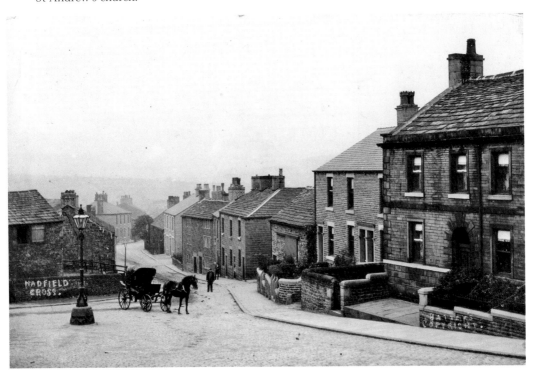

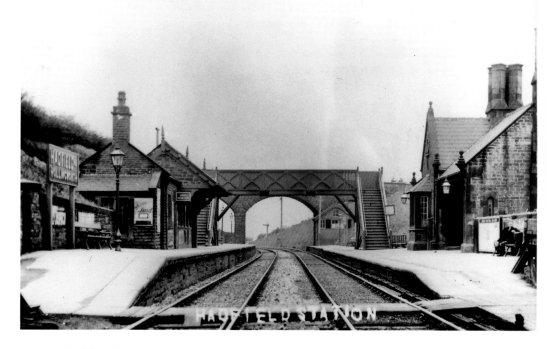

Hadfield Railway Station

At the height of the railway age some steam, diesel and later locomotives with goods and/or passengers went straight through Hadfield on to Sheffield and beyond. The recent photograph shows only a single line and platform with passenger trains from Manchester terminating at Hadfield. The footbridge has long gone and the only overhead structure is the gantry for the electrified line used daily by hundreds of commuters.

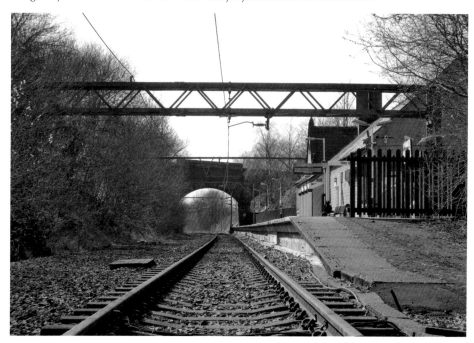

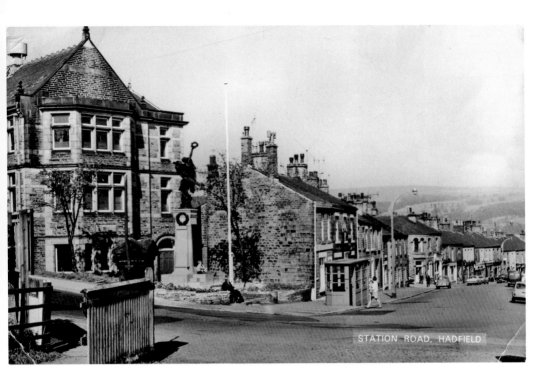

STATION ROAD, HADFIELD

Hadfield Hall and Library

Hadfield Hall and Library was built by Edward Platt, mill owner in 1905. The hall has recently been refurbished and brought back to regular use as a useful venue for community groups and associations. Little has changed with the exception of a new pedestrian safety barrier surrounding the war memorial and its gardens. The concrete bus shelter has been replaced and this 'top of the street' location is still a bus stop.

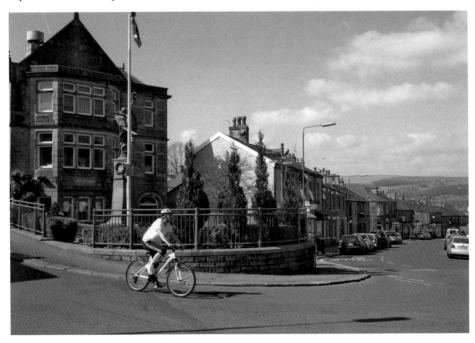

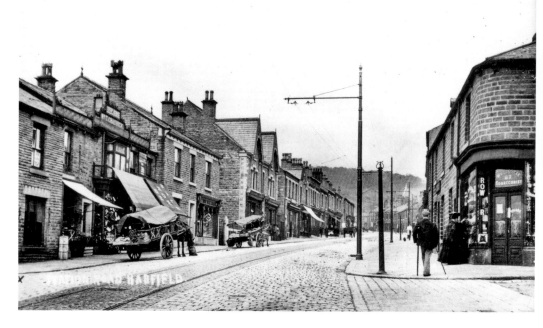

Station Road, Hadfield

This view is taken from outside the former Masons Arms pub looking towards the railway station and is probably one of my favourite old images of Hadfield; one of the author's grandfathers, Clifford Thompson was born above the shop on the right, 82 Station Road, on 10 September 1896. The horses with their drays would be out of place today outside the neatly expanded and re-furbished Londis general store.

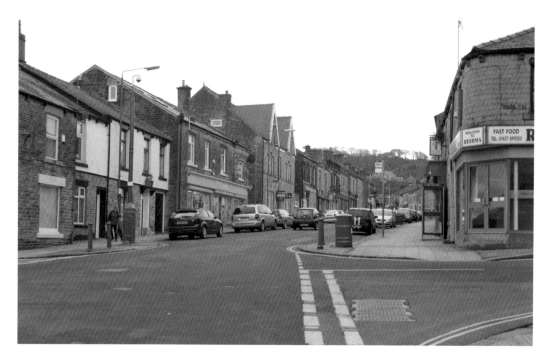

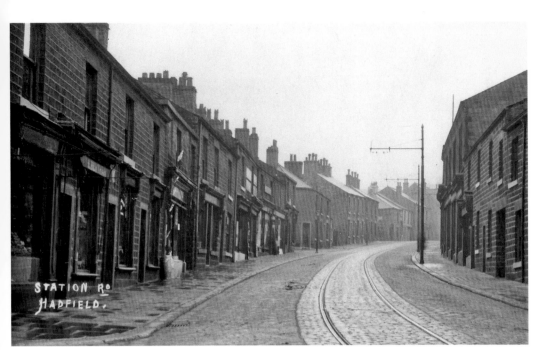

Station Road, Hadfield at the Junction with Albert Street

A lovely old view of a deserted lower Station Road at its junction with Albert Street showing an empty tram track. Today the view has changed little except the demolition of cottages on the right has made way for a car park and the constant traffic makes it near impossible to get an uninterrupted photograph.

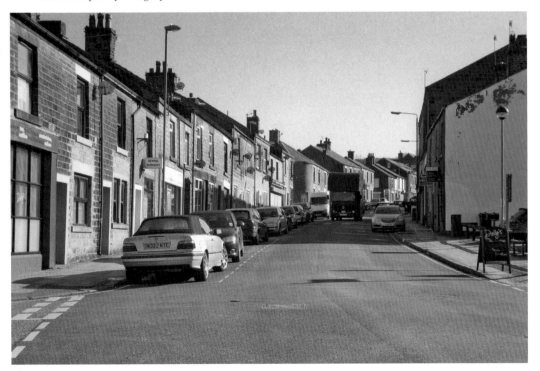

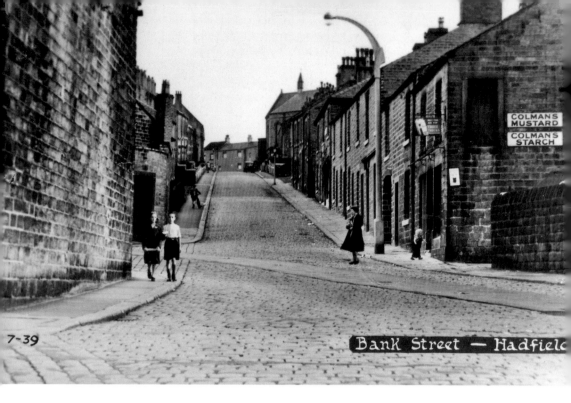

7-39

Bank Street — Hadfield

Bank Street, Hadfield

Bank Street from its junction with Station Road. On the left hand side at the top of Bank Street was a factory 'Mentor' who manufactured gentleman's shirts in a building which was the former Liberal Club and is now residential apartments. Opposite this stood the Bank Street Methodist church destroyed by fire in 1997 and now residential properties. The Lamp Inn on the corner of Bankbottom is still a lively social venue.

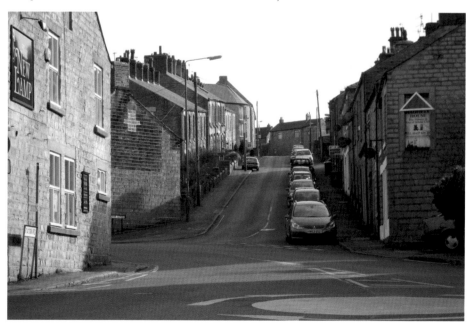

New Road, Tintwistle

New Road connects Hadfield with Tintwistle and the A628 trunk road. The lovely view of a cobbled road is virtually unchanged. The former Church Inn stands proudly at the hilt. Today it is difficult to get a traffic free view; this was taken as the refuse collection vehicle was blocking the passage of traffic!

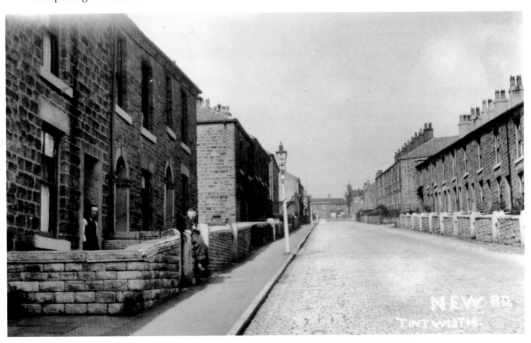

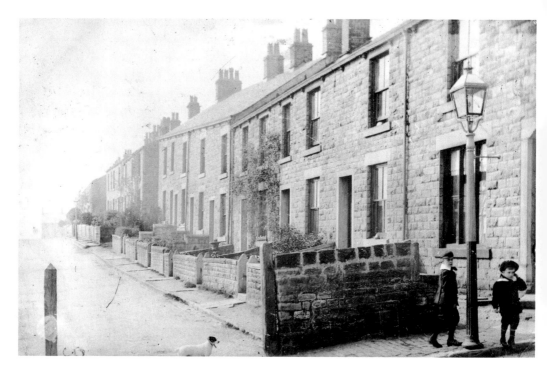

Conduit Street, Tintwistle

These photographs are taken almost 100 years apart and not a lot has changed on Conduit Street except for the lampposts and children in their 'Sunday School best'. Of course, these days vehicles are an inevitable and necessary part of everyday life. No building has taken place on the left hand side, 'The Rec'.

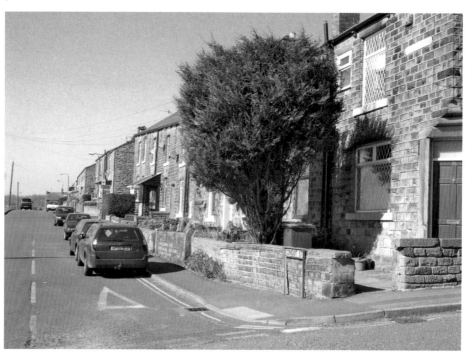

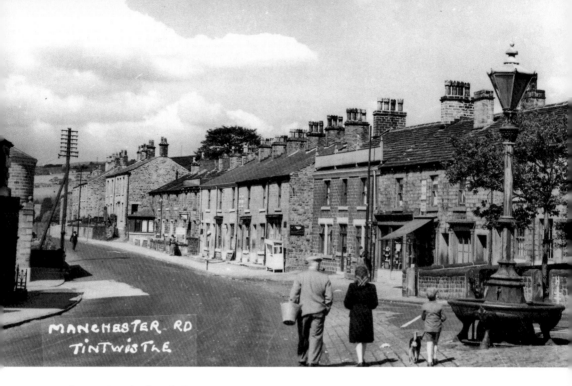

Manchester Road, Tintwistle

The older view was taken *c.* 1960 and shows the Church Inn amidst the row of busy shops with the Old Oak Inn further along the row. It is difficult to imagine how quickly the main road has become so busy. Does Tintwistle need a bypass?

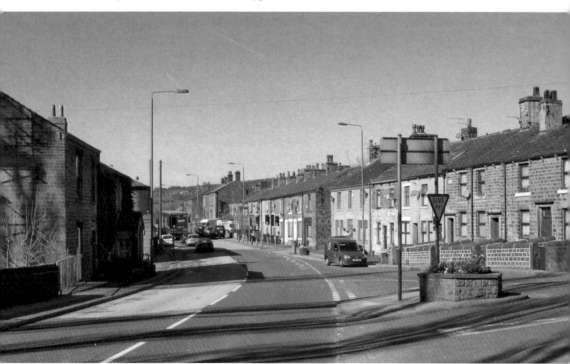

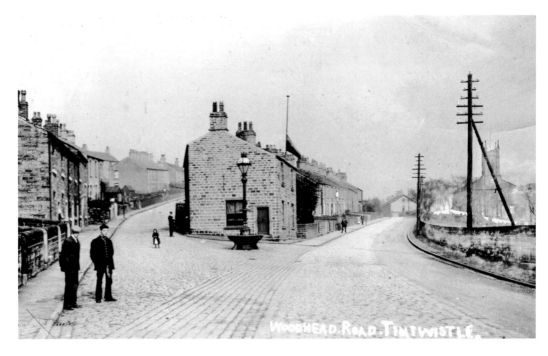

Church Street, Tintwistle
A lovely old photograph which is wrongly titled! This view is Church Street towards Woodhead at its junction with Old Road. One or two residents are posing for the photographer but there is no sign of any vehicles. The fountain was installed *c.* 1902 and looks quite new. Some noticeable differences are the growth of traffic and vegetation.

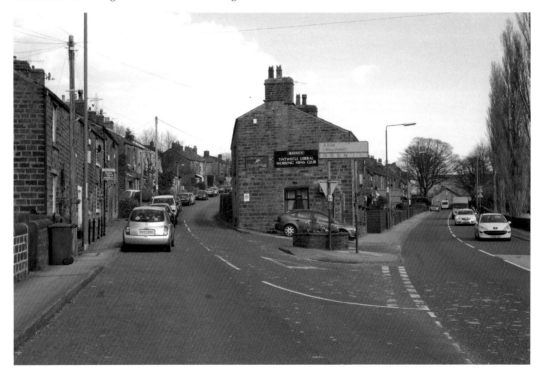

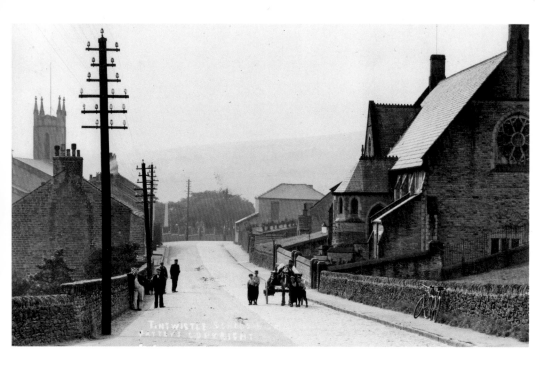

Church Street, Tintwistle, *c.* 1880

A view along Church Street looking west. The laden cart with its bystanders would not be able to pose in the same location today due to the heavy traffic along this stretch towards the M67 motorway at Mottram. I was lucky with the newer shot that there were some temporary traffic signals nearby holding up the traffic which enabled this unrestricted view.

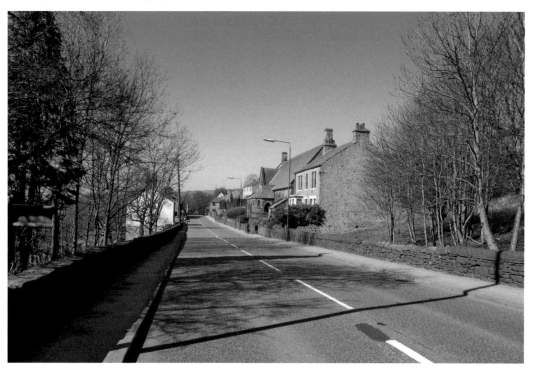

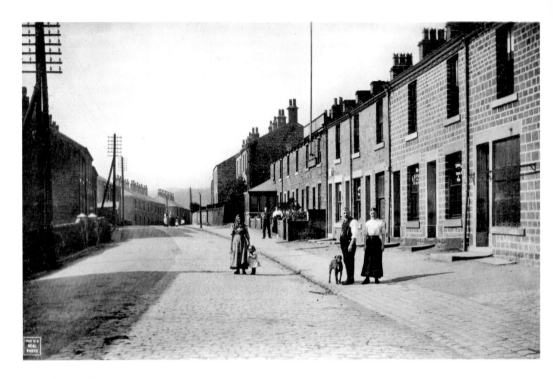

Manchester Road, Tintwistle

How startling that the group of pedestrians in the old picture are in almost exactly the same spot as the new pedestrian crossing! Nearly all of the shop and business premises along this stretch are now residential dwellings. Some telegraph poles remain *in situ* though.

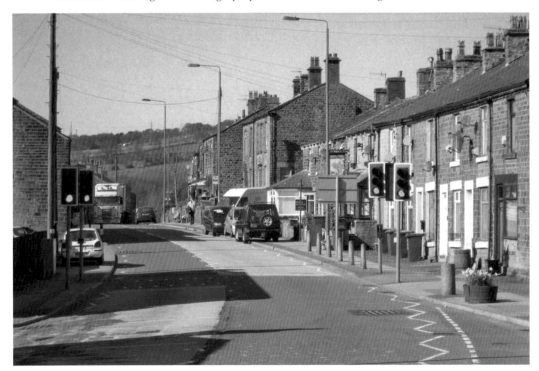

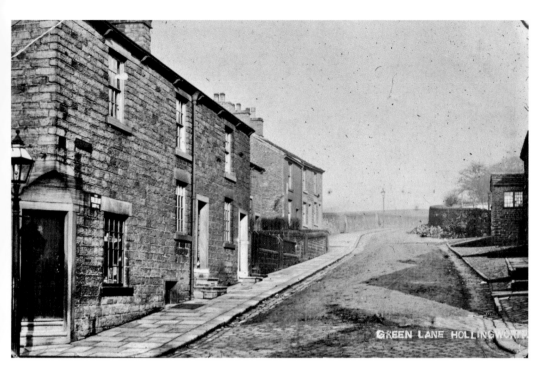

Green Lane, Hollingworth
These days Green Lane leads to many more houses than it did in the early view. The road layout appears the same and the interesting doorway of the old shop on the left remains. The gas street lamp has been replaced by a traffic sign on the opposite side.

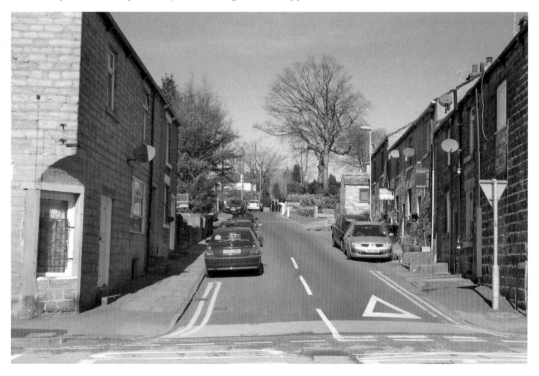

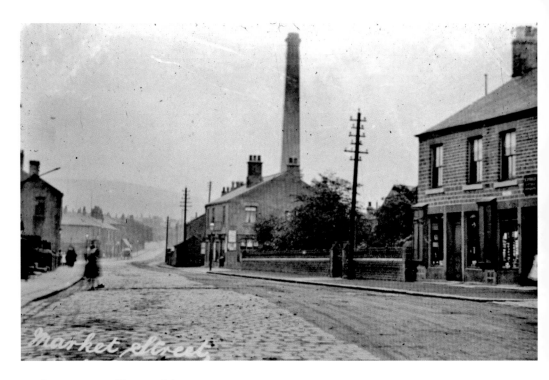

Market Street, Hollingworth

From the top of Booth Street looking east along Market Street. Arrowscroft Mill chimney dominates the right hand side. This was demolished after a fire to make way for a new housing development. The shops remain virtually unchanged as does the situation of the telegraph pole. This busy A628 trunk road is rarely so calm and almost traffic free as this Sunday afternoon in April.

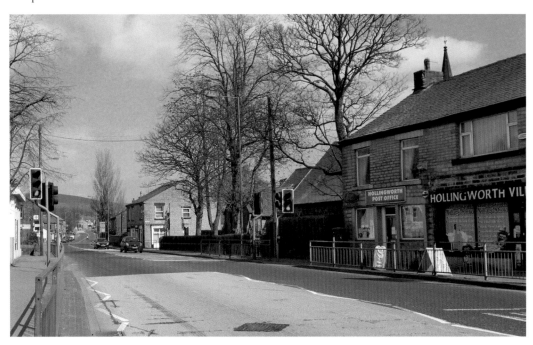

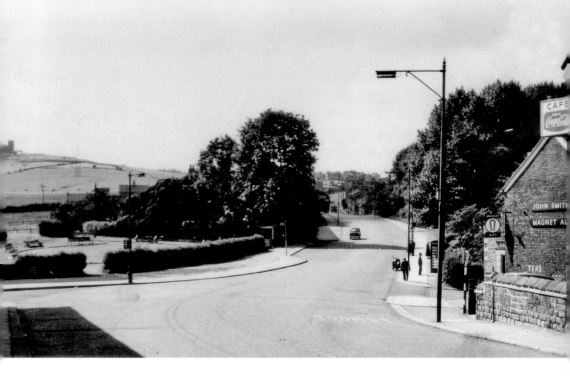

Mottram Moor, Hollingworth

How times change. Until we studied the older picture we did not realise that the traffic lights and most road markings were missing. The recent view was taken on a Sunday afternoon in April so that the traffic is much lighter than usual. Mottram Church on the skyline is obliterated by tree growth. The original name for Mottram Moor was Treacle Street.

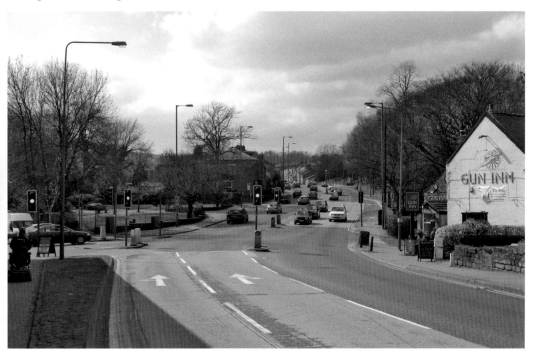

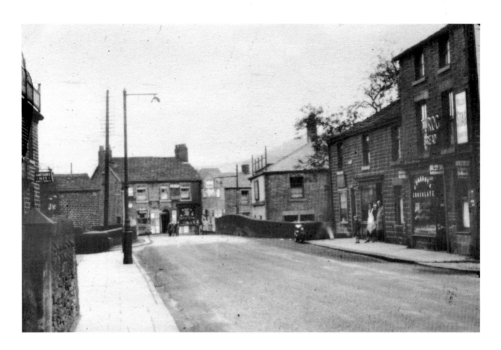

Woolley Bridge

A view every commuter from this area sees daily. The bridge over the River Etherow remains the same. In the older photograph a three-storey baker's shop sits next to two cottages and a small child stands in the road. Two pubs – the Woolley Bridge Inn and the Spread Eagle Hotel – are both still standing but neither is in use for the sale of alcohol. Cottages on Lees Street in the distance are now replaced with Glossop Caravans and a housing estate in the distance.

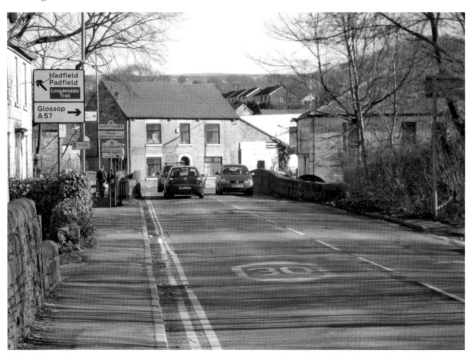